IMAGES
of America

IRISH SEATTLE

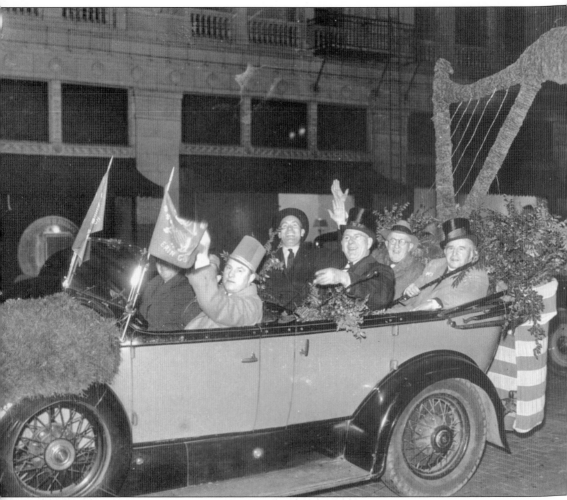

ON THE COVER: St. Patrick's Day has been celebrated annually in Seattle since the late 1800s, oftentimes involving impromptu, unofficial parades like the one above in 1936. It was not until 1972 that the City of Seattle issued the first official permit for what was initially called a "St. Patrick's Day Religious Procession" on Seattle's main downtown streets. (Courtesy Museum of History and Industry [MOHAI], *Seattle Post-Intelligencer* Collection, 86.5.6939.)

IMAGES
of America

IRISH SEATTLE

John F. Keane
Irish Heritage Club

ARCADIA
PUBLISHING

For all general information contact Arcadia Publishing at:
Telephone 843-853-2070
Fax 843-853-0044
E-mail sales@arcadiapublishing.com
For customer service and orders:
Toll-Free 1-888-313-2665

Visit us on the Internet at www.arcadiapublishing.com

Dedicated to all whose hearts were broken when they left Ireland, and to those who welcomed them and made them feel at home in this new land. In my case, that applies to my cousin Olive and her husband, Pat Doohan, and to Grá mo Chroí, my wife, Maureen.

A STREET OF COBBLE-STONE

Sure my feet are never weary, and it don't seem far at all
As I tramp the hills and valleys, back to dear old Donegal
And when I reach the end of it, it's young my heart has grown,
As I pause beside a cottage, on a street of cobble-stone.

Sure I hear the Shannon rolling, on its way towards the sea,
And I listen to the sky-larks, where the Colleen waits for me;
And I sit us down together, on a stile that we had known,
In years of childhood's roaming, on a street of cobble-stone.

So if comfort you would bring me, then my only wish would be
Give Ireland to the Irish, for I love her — Gra Machree
And 'tis then my heart would revel in scenes that I have known
With a Colleen in a cottage, on a street of cobble-stone.

(Thomas J. Cronin)

This poem was printed in the May 1, 1925, issue of the *Island Lantern*, the newspaper at McNeil Island Penitentiary near Olympia. (Poem courtesy Kay Quinlan.)

CONTENTS

ACKNOWLEDGMENTS

The author thanks all those who trusted him with their precious photographs and memories of their Irish parents and grandparents. Sincere thanks to Leo Costello for his collection of photographs and mementos that started the process; his brother John for loaning copies of Clarence Bagley's invaluable *History of King County*; Tom and Kay Quinlan who shared their tremendous collection of family photographs and artifacts; Mary and Frank Shriane whose memories of Irish Seattle are priceless; Kathleen Donahue for her stories of her grand-aunt, the "Queen of Alaska," and Joanne King who helped document them; Gov. John Spellman for his impromptu guided tour of downtown Seattle's Prefontaine monuments; Cáit Callen for her memories of Joe Heaney; Finian Rowland, Colleen Kryszak, and Eileen Pat Dunn for sharing tea and scones along with stories and photographs; Brendan and Diane Gallagher for going the extra mile; Joey Cheatle for the legwork at Seattle U; Michael O'Sullivan of Wee Bit; Margaret Riddle at the Everett Library; Brother Greenan at O'Dea High; Caroline Marr at MOHAI; and Nicolette Bromberg at UW. Special thanks to Melissa Estelle and Mary Shriane for providing feedback, to good friend Fr. Joe O'Shea for resources and advice, and to patient wife Maureen for her encouragement and support. Míle Buíochas, a thousand thanks to all.

INTRODUCTION

This is an attempt to chronicle some of the more interesting characters and individuals of Irish birth, extraction, or reputation who helped shape the Seattle area, as well as to provide a feel for the Irish community that has existed in Seattle since the city was first settled in 1851.

These are snapshots only, ones that touch on some of the accomplishments of the people profiled. There are many other worthy and prominent individuals of Irish background who are not profiled here, but space and time do not allow that long a story. The hope is that the reader's curiosity will be piqued enough to warrant further investigation. All of the individuals described in this book are interesting people who contributed immensely to the wonderful place that is Seattle today. They also happen to be Irish.

It is not surprising that Irish people would be attracted to the Pacific Northwest. The area's climate—with its cool, damp winters and warm summers—is very similar to Ireland's. The Puget Sound area's great mix of rugged coastline and mountain backdrops would be very familiar to anyone born in Ireland. The only problem with Seattle from an Irish perspective is that it is so far away from home.

That there were so many prominent Irish in the early days of Seattle should not be surprising when you consider that about 800,000 Washingtonians claimed Irish ancestry in the 2000 Census. Irish ancestry is shared by the governor of Washington, the state's two U.S. Senators, Seattle's U.S. Congressman and mayor, and many other prominent individuals in legal, medical, and other professions. Yet, despite so many citizens of Irish birth or extraction in the area, Seattle would never be called an "Irish city" like Boston or Chicago, possibly because the Irish did not congregate in Irish neighborhoods here like they did in some cities back east.

In 1890, over two million Irish-born people lived in the United States out of a total national population of 90 million. Today there are about 128,000 Irish-born people in the United States, with probably fewer than 2,000 of them in the state of Washington.

In the 1800s, most immigrants from Ireland settled on the East Coast because that's where they had relatives or friends and because they didn't have the necessary resources to proceed farther west. The financial cost of coming to America in the 1800s left thousands penniless upon arrival. It was also an extremely dangerous adventure, as thousands of lives were lost on ships crossing the Atlantic. With the terrible conditions onboard, some of those who survived were often deathly ill upon arrival. In 1847, the worst year of the Irish famine, the Canadian quarantine station at Grosse Isle reported 9,572 deaths from disease contracted onboard ships crossing the Atlantic.

But many of those who arrived safely did venture out. On the frontier, they had more freedom to pursue their dreams. The huge westward expansion that occurred in the 1870s attracted the Irish as railroad-construction workers, coal miners, loggers, and homestead farmers. The U.S. Army brought many west as cavalrymen to establish federal military posts and as fighters in the

Indian wars. Many of these Irish were born in Ireland, but many others were second-generation Irish who had grown up in Irish neighborhoods back east.

By and large, these adventurous Irish became hugely successful—as farmers, prospectors, lawmen, and politicians. Numerous towns were platted by Irishmen and named for themselves, their wives, or areas back home. The Irish were at the forefront in establishing schools and churches, and they were especially at the forefront as priests, politicians, policemen, and firemen.

The Irish are still here in the Seattle area and still have that huge emotional connection to Ireland, passed down through generations. That is especially so of the descendants of those who were forced to leave Ireland because of famine, poverty, and persecution.

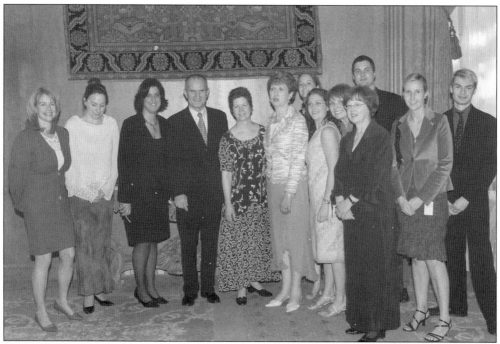

In May 2005, members of Seattle's Irish Heritage Club and Seattle Gaels pose in Seattle with Irish president Mary McAleese; the first time since Eamon de Valera in 1919 that a president of the Irish Republic visited Seattle. Pictured here from left to right are Noreen McCormack, Gerrarda O'Beirne, Heidi Kinsella, Dr. Martin McAlesse, Nanci Spieker, Pres. Mary McAleese, Meg Seyler, Rebecca Fox, Edie Henderson, Agnes Roche, Alex Terzieff, Sylvia McLaughlin, and Micheál Keane. (Courtesy Jal Schrof.)

One

PIONEERING DAYS

When the Great Irish Famine started, in 1845, there were only a few non-native settlers plus some prospectors and trappers in what is present-day Washington state. The Hudson's Bay Company's representative, the chief factor, governed Oregon Territory, a huge area covering all of today's states of Oregon, Washington, and Idaho and large parts of British Columbia, Wyoming, and Montana. In 1846, two years after the first American settlers headed north of the Columbia River, the United States and Britain agreed on the 49th parallel as the U.S.–Canada boundary. Seven years later, in 1853, just as Ireland was emerging from the famine, Washington Territory was created.

Before the transcontinental railroad was completed in 1869, it was an arduous journey to travel from the East Coast to today's Seattle. The options were eight months by ship around Cape Horn, five to six months via wagon train to Portland, or two to three months via ship to the east coast of Panama, across the Isthmus of Panama, and then on another ship to San Francisco and farther north. Even in the Seattle area, it was time-consuming and difficult to get around. Nothing was easy, and the people who came to this area before 1890 legitimately earned the title pioneer. Prominent among them were the Irish.

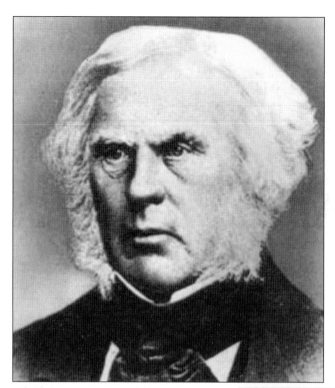

Dr. John McLoughlin (1784–1857), who grandfather (and possibly his father) was from County Donegal, was born in Quebec and, from 1825 to 1845, was chief factor of the Hudson's Bay Company at Fort Vancouver, the center of British dominion over Oregon Territory. He made Fort Vancouver the cultural center of the Pacific Northwest and was knighted by the pope in 1847 for his charitable deeds.

John Denny, grandson of David and Margaret Denny from County Kerry, led a wagon train west from Indiana to Portland in 1851. His son David Denny, pictured at right, and two companions came north to Elliot Bay, landing on September 25, 1851. While waiting for the others to arrive from Portland, Denny built a cabin and became the first white man to settle the area. The group later changed the area's name from Duwamps to honor their new Native American friend, Chief Seattle. (Courtesy C. Bagley.)

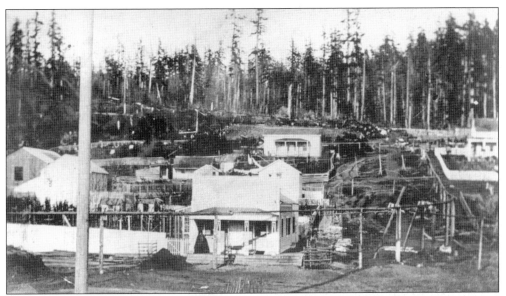

Taken in 1860, the earliest known photograph of Seattle shows downtown at First Avenue and James Street. Henry Yesler's house is at center, while the house on the extreme right was later owned by John Collins from County Cavan. Coming down the hill and curving in front of Yesler's home is the flume carrying water to homes and businesses. From 1889 to 1892, Yesler's housekeeper was Bridget Manion from County Galway. (Courtesy MOHAI, SHS-6683.)

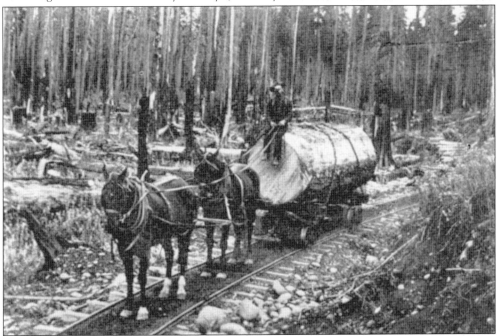

The first Irish in Seattle were loggers, and Seattle's early logging industry was dependent on lumber being shipped to San Francisco to supply the gold rush–generated housing boom. From 1853, trees were skidded down from the hills to Yesler's sawmill on the waterfront along "Skid Road." Later logging railroads were built, like the one pictured above near Enumclaw, more easily permitting logs to be harvested. (Courtesy C. Bagley.)

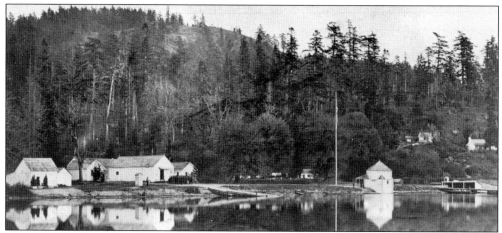

In 1859, an American settler shot a Hudson's Bay Company pig on San Juan Island in Puget Sound, which at that time was claimed by both the United States and Britain. The resulting "Pig War" had both governments stationing troops on the island. Pictured above in 1865 is the English camp at Garrison Bay. The standoff ended without further shooting in 1870, when an international panel ruled for U.S. ownership. In 1860, at the height of the conflict, 43 of the 73 U.S. enlisted men stationed on the island were Irish born. (Courtesy UW Digital Collections, UW-10985.)

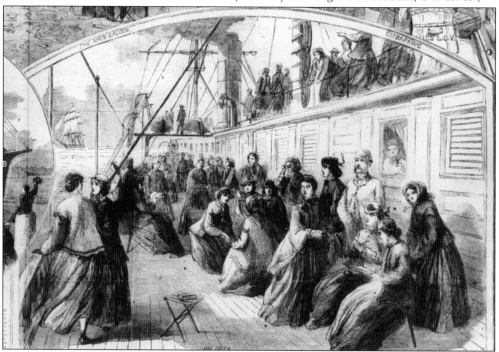

The *Here Comes the Bride* 1960s television show was based on Asa Mercer's recruitment of young women back East to come to Seattle to balance the male/female population. In 1864, Mercer's first group of women traveled by train from Massachusetts to New York, via steamship to Panama, by train across the Isthmus, and again via ship to San Francisco and Seattle, arriving after a two-month journey. Among the 11 women in that first group were Irishwomen Sarah Gallagher and Ann Murphy. Above is the *Harper's Weekly* 1866 illustration of the scene onboard the steamship. (Courtesy UW Digital Collections, WARNER-68x.)

Among the first "Mercer Girls," Sarah Jane Gallagher (1845–1897) was born in Boston, the daughter of Irish immigrants. She arrived in Seattle on May 16, 1864, her 19th birthday. In 1865, she married widower Thomas Russell, and their son George later became Seattle's postmaster. After Thomas's death in 1882, Sarah operated the Russell Hotel, the only hotel to survive the great Seattle fire of 1889. (Courtesy UW Digital Collections, WARNER-3165.)

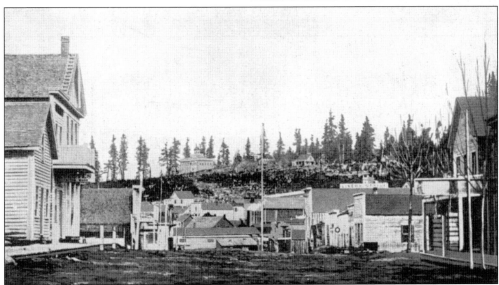

Sarah Gallagher taught music at Washington Territorial University (pictured above in the distance in 1866), and one of her students there was Clara McCarty who, in 1876 at age 18, was the university's first degreed graduate. The oldest public university in the western United States, Washington Territorial University was established in 1861, when the non-native population of King County was about 300. (Courtesy C. Bagley.)

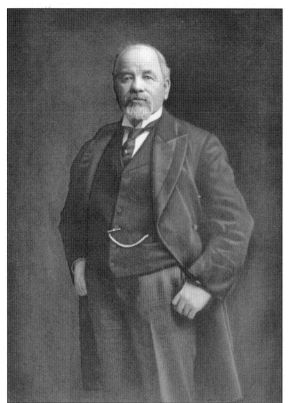

Born in New York of Irish immigrant parents, Thomas Burke (1849–1925) came to Seattle in 1875. He became a civic leader, a railroad promoter, a champion of the university (UW), a voice of tolerance during the 1886 anti-Chinese riots, and chief justice of the Washington Territorial (later state) Supreme Court in 1889. UW's Burke Museum and the Burke-Gilman Trail are named for Burke, also known as "The Man Who Built Seattle." (Courtesy C. Bagley.)

Born in Belfast in 1849, William P. Boyd came to San Francisco in 1869 and to Seattle in 1872. In 1878, he went into business operating a small dry goods store that later became W. P. Boyd and Company, one of Seattle's largest. Pictured below in 1878, his dry goods store is on the left of Seattle's First Avenue looking north from Yesler Way towards Denny Hill. (Courtesy UW Digital Collections, A.CURTIS-05317.)

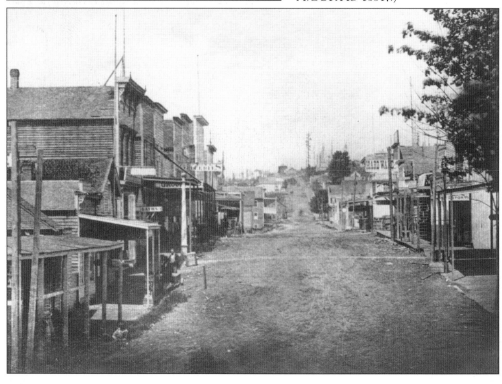

Thornton F. McElroy (1825–1885) was the son of a Methodist clergyman from Ireland. Married in 1847, he left his wife behind in Illinois in 1849 and traveled by wagon train to Portland where he worked for the *Oregonian*. He later came to Olympia to publish Washington's first newspaper, the *Columbian*. In 1854, his wife joined him, and by 1872, McElroy was one of the wealthiest men in the territory. He served as mayor of Olympia in 1875 and died in 1885. (Courtesy UW Digital Collections, UW-18452.)

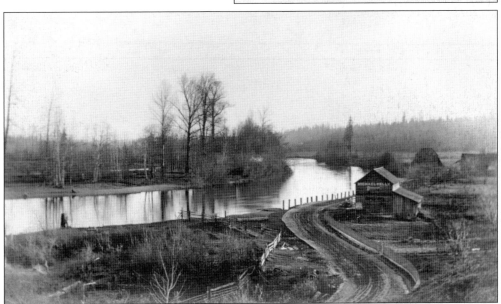

In the early 1870s, Mike and Jane Kelly farmed the banks of the Duwamish River at these farm buildings, photographed in the 1890s. In 1875, they moved their homestead to an area they named Sunnydale, north of the present-day Sea-Tac Airport. As the first settlers there, their barn became Sunnydale's community meeting place, and their kitchen was the schoolhouse. Mike built Kelly Road, which today is called Des Moines Memorial Drive. (Courtesy MOHAI, 2002.50.87.)

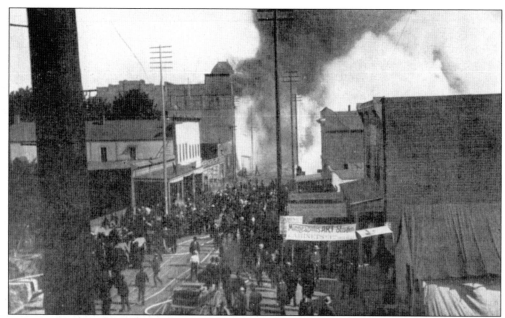

On June 6, 1889, Seattle's downtown went up in flames in the great fire. Acting fire chief James Murphy was in charge of the volunteer fire department, and fellow Irishman and mayor, Robert Moran, later assumed control of the firefighting but to no avail. The fire burnt itself out after 30 blocks of downtown Seattle were in ruins, hundreds of businesses destroyed, and 5,000 jobs lost. Somehow, nobody died. (Courtesy C. Bagley.)

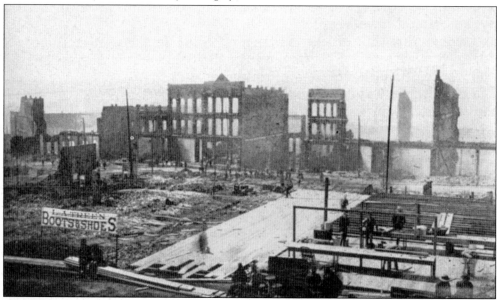

Jimmy McGough (1850–1910), from County Monaghan, was initially identified by the *Seattle Post-Intelligencer* as having started the fire. (The ruins are seen here on June 7.) The paper corrected itself later, but McGough's glue pot remains a Seattle legend, much like that cow in Chicago. McGough fought the fire as a member of the Seattle Fire Department and was one of Seattle's most prosperous citizens when killed in a horse-and-buggy and streetcar accident in 1910. (Courtesy C. Bagley.)

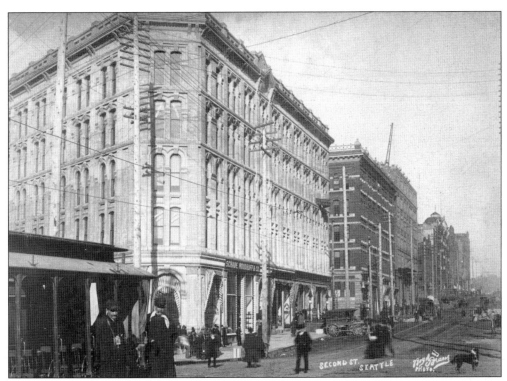

After the great fire, city officials approved new building codes requiring structures to be made of brick and stone. Within 12 months, 465 new buildings were built, and the city's population almost doubled to 42,000, all because of new construction jobs. Pictured above in 1890 is downtown Seattle looking north on Second Avenue from Yesler Way with the Collins building (later named Hotel Seattle) on the left. (Courtesy UW Digital Collections, UW-12069.)

Born in County Cavan, John Collins (1835–1903) became a Seattle entrepreneur, investing in coal, banking, hotels, public utilities, publishing, and more. He served four terms on Seattle's city council, from 1869 to 1883, and was Seattle's fourth mayor in 1873, "a rare Catholic Democrat among the city's Protestant Republican ruling class," according to local historian Paul Dorpat. He served in the territorial legislature in 1883, and his Occidental Hotel was destroyed in the great fire. At his death, his estate included the Collins Building that still stands at Second and Yesler (beside the Smith Tower). (Courtesy MOHAI, SHS-10797.)

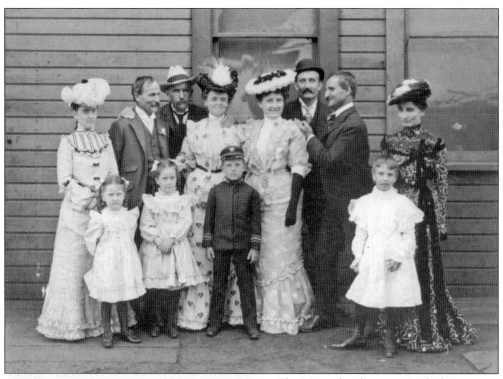

The Moran brothers pose with their wives and children around 1903. Robert Moran (1857–1943) was born in New York, the grandson of a man who left Ireland in 1826. Robert came west in 1882 and started a marine repair shop in Seattle with his brothers. In 1888, he was elected mayor and again in 1889 following the great fire. The Moran brothers went into shipbuilding, and the company prospered during the Klondike gold rush. Moran retired in 1906, built Rosario Resort, and donated the land for Moran State Park. (Courtesy MOHAI, 2000.87.18B1.)

John Harte McGraw (1850–1910), whose parents were born in Ireland, came to Seattle in 1876. In 1893, he was elected governor of Washington on a platform calling for construction of the Lake Washington Ship Canal. When his term expired in 1897, McGraw went prospecting for gold in the Klondike. He returned to Seattle, became president of the chamber of commerce, and helped organize the 1909 Alaska-Yukon-Pacific Exposition, Seattle's first World's Fair. (Courtesy C. Bagley.)

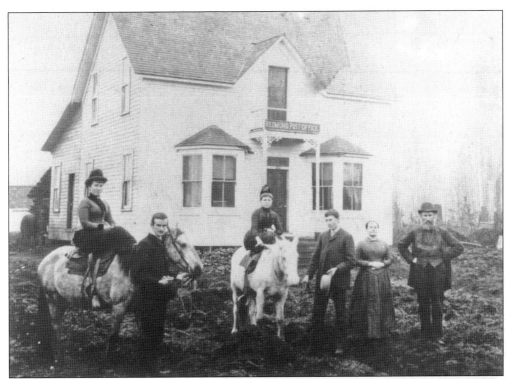

In 1886, Kate and Luke McRedmond (right) pose with their children outside their home, also the Redmond post office. McRedmond (1818–1898) was born in County Offaly and mined for gold in California. He came to Washington in 1871 and farmed the Sammamish Valley. He planned a town, and in 1882, named it Redmond. McRedmond died 87 years before Microsoft choose his town to be the location for its world headquarters. (Courtesy Eastside Heritage Center.)

John McQuade (1863–1934), born in County Tyrone, prospected for coal at Newcastle and Cedar Mountain in the 1880s, and later at Roslyn and Issaquah. He served as Gilman town marshal (now Issaquah) from 1892 to 1899, when he went prospecting for gold in the Klondike. In 1900, he returned and settled into coal mining at Cedar Mountain, becoming one of the most successful mine operators in the area. (Courtesy C. Bagley.)

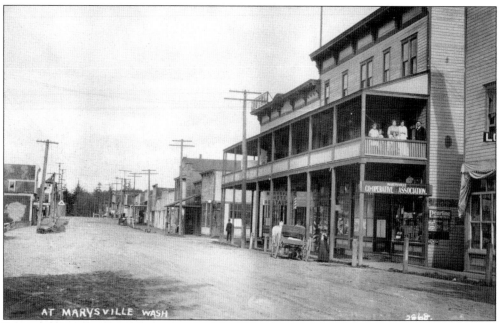

At Marysville Wash

Born in Ireland, James (1833–1909) and Maria (1846–1904) Comeford came to the Tulalip Indian Reservation, 30 miles north of Seattle, in 1872. In 1878, they purchased land off the reservation and established a trading post and town called Marysville (pictured above around 1913). James named it for his wife, changing the name from Slup-puks. Maria taught school in their home, and the first Catholic Mass in Marysville was held there in 1886. (Courtesy UW Digital Collections, UW-26604z.)

James M. Geraghty (1870–1940) was born in County Mayo, and his family immigrated to Indiana in 1880. In the later 1880s, Geraghty came to Spokane where he worked as a teamster. He served as a state representative in Olympia in 1897, as Spokane's city attorney from 1905 to 1932, and as a Supreme Court justice in Olypmia from 1933 until his death in 1940. (Courtesy grandson Jack Geraghty, former mayor of Spokane.)

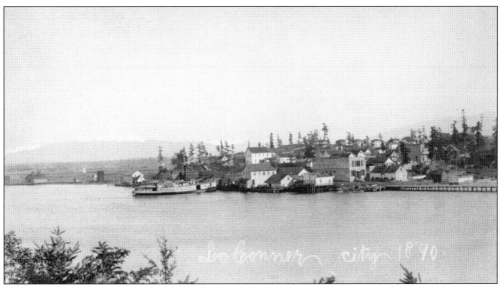

John Conner arrived in 1869, landed on the Swinomish slough 65 miles north of Seattle, and operated a trading post. His cousin James Conner joined him and claimed 160 acres of land for farming. In 1872, James laid out the town of LaConner, naming it for his cousin's wife, Louisa Ann. James also prospected for coal at Coal Mountain. Pictured above is LaConner in 1890 across the Swinomish Channel with Mount Baker in the background. (Courtesy UW Digital Collections, UW-6919.)

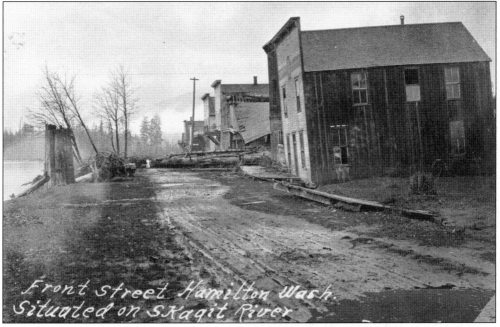

James O'Loughlin, born in 1844 in County Clare, partnered with fellow Irishmen James Conner and James Scott in 1875 to prospect at Coal Mountain near Hamilton, pictured above in 1898 after severe flooding. The mine produced tons of coal but, because of logjams on the Skagit River, had to be brought via canoe down the river for shipment to San Francisco. In 1877, O'Loughlin left the coal mining to his partners and turned to farming. (Courtesy UW Digital Collections, UW-4378.)

John Miller Murphy (1938–1916) was born in Indiana, son of an Irish immigrant. In 1850, he came by wagon train to Portland and worked for the *Oregonian*. In 1860, he came north to establish Olympia's *Washington Standard*, whose first edition reported Lincoln's election as president. Murphy later founded the *Daily Olympian*, and he and his partner, Clarence Bagley, alternated days editing the newspaper because Murphy was a Democrat and Bagley a Republican. (Courtesy UW Digital Collections, UW-5969.)

Mary Charles, left, from County Leitrim, and Finian Rowland, right, from County Mayo, flank the Fairhaven Village Green statue of Dan Harris. The son of Irish immigrants, Harris (1826–1890) came to Bellingham Bay in 1853 and spent 30 years farming, fishing, and smuggling from Canada! Affectionately known as "Dirty Dan," Harris platted the town of Fairhaven (now part of Bellingham) in 1861. He became a real estate magnate and accumulated a fortune. In 1883, he married and relocated to Los Angeles.

Two

THE GOLD RUSH AND ITS AFTERMATH

The *Seattle Post-Intelligencer* headlines in July 1897 read, "GOLD! GOLD! GOLD! GOLD! STACKS OF YELLOW METAL!" The paper was reporting that the steamship *Portland* had arrived in Seattle carrying almost two tons of gold from the Klondike goldfields. Klondike hysteria took over, and people all across the United States were galvanized by the thought of the riches available. A wave of migration to the Klondike started, with most prospectors going through Seattle. Thousands of Irishmen joined them, leaving jobs in California, Montana, and all across the United States—all for the chance of the big strike.

Mícheál MacGowan from County Donegal was one of those prospectors going through Seattle to the Klondike in 1898. In his book *Hard Road to Klondike*, he wrote, "About this time—autumn 1898—it looked as if the whole world was on this route. People from the four corners of the world were on the streets of Seattle—and more coming with each day that passed—miners and other workers like ourselves who had thrown up whatever work they had to go looking for gold in Alaska—servants from the cities, cowboys from Texas, clerks from offices, shopkeepers, outlaws, gamblers and other tricksters that never held in their hand any tool heavier than a spoon."

Seattle's population went from 42,837 in 1890 to 80,671 in 1900 and to 237,000 in 1910. The Klondike made Seattle a city.

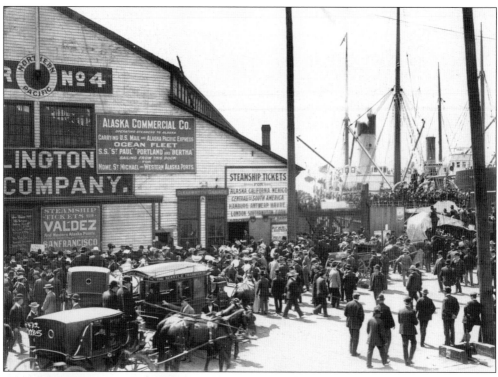

On July 17, 1897, the steamer *Portland* docked in Seattle carrying an estimated two tons of gold from the Klondike. City leaders deliberately set about selling Seattle as the best place to outfit on the way to the Klondike, and thousands thronged the city heading north, including thousands of Irishmen. Seattle's population and economy thrived. (Courtesy UW Digital Collections, W&S-4712.)

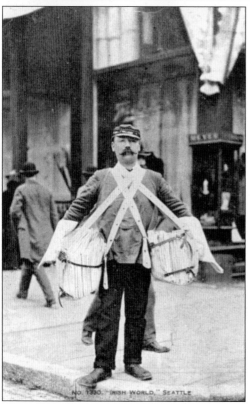

There were so many Irish in Seattle during the Klondike gold rush that, here, a Seattle street vendor hawks the *Irish World* newspaper, which was widely sold in Irish communities across the United States. Patrick Ford, editor of the *Irish World*, was born in Galway, and after fighting on the Union side in the Civil War, he started the paper in New York in 1870. (Courtesy MOHAI, 2002.48.852.)

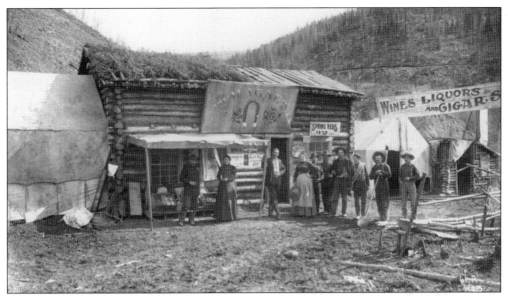

Belinda Mulrooney (1872–1967) left County Mayo in 1889 and became an entrepreneur, first at Chicago's 1893 World's Fair and then on the West Coast. In 1897, she went to the Klondike and became wealthy selling supplies to miners, running the Magnet Roadhouse in Bonanza (pictured above in 1898), and later a fancy hotel in Dawson City. Once dubbed "The Richest Woman in the Klondike," she lost her fortune through a fake French count who scammed her. She later settled in Yakima and then in Seattle, where she died in 1967. (Courtesy UW Digital Collections, HEGG-794.)

In 1898, Donegalman Mícheál MacGowan hopped a train to Seattle from Butte, traveled by steamer to Alaska's St. Michel and up the Yukon River, and spent four more months walking 300 miles to the goldfields. In 1901, MacGowan returned to Ireland with his fortune, raised a family, and died in 1948. His adventures are chronicled in *Hard Road to Klondike*, and one chapter is titled "Life in Seattle." He could have traveled on the steamer *Roanoke*, pictured above ready to leave Seattle for the Klondike in June 1898. (Courtesy UW Digital Collections, WILSE-872.)

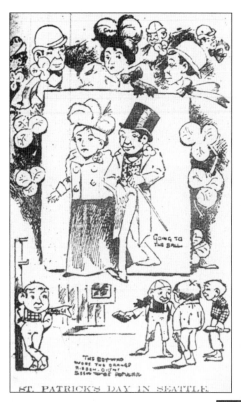

A *Seattle P-I* cartoon from March 18, 1899, shows Seattleites celebrating St. Patrick's Day in style. The message at the bottom says, "The boy who wore the orange ribbon did not seem to be popular." It is not the earliest record of St. Patrick's Day being celebrated in the state; a St. Patrick's Day Ball was held in 1866 in a hotel in Vancouver on the north side of the Columbia River. (Courtesy *Seattle Post-Intelligencer*.)

Born in New York in 1866, the son of Irish immigrants, John T. Heffernan was a railroad engineer who came to Seattle in 1889. He became a noted mechanical engineer, building engines for Klondike gold-rush steamers and the Puget Sound "Mosquito Fleet." His engine still powers the *Virginia V*, Seattle's propeller-driven wooden steamer. A civic leader, he served on the UW Board of Regents and helped found the St. Vincent Home for the Aged. (Courtesy C. Bagley.)

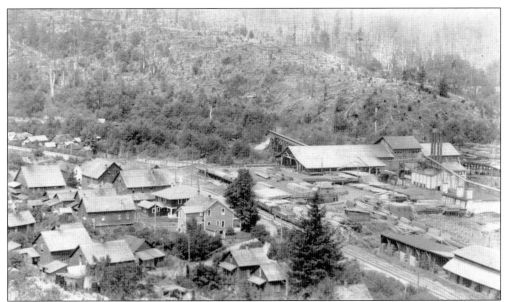

From the 1850s, large numbers of Irish were involved in logging-related industries in Washington, many building their own lumber mills and lumber camps. The town of McCormick, pictured here in 1909, was platted in 1899 by Harry McCormick, who built a company town with 85 houses, a church, and a schoolhouse—all with electric light, running water, and a sewer system. The company went out of business about 1936, leading to the town being nearly abandoned. (Courtesy Ed Schultz.)

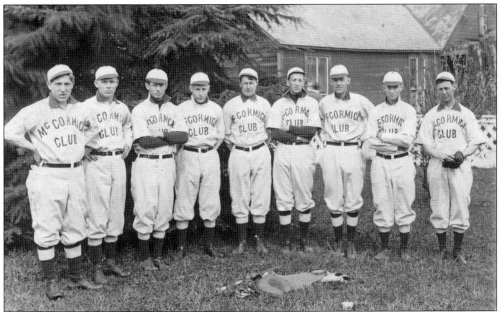

The McCormick baseball team, sponsored by the lumber mill, probably played in the Timber Baseball League, one of the most popular baseball leagues in Washington from the 1890s through the 1930s. Amateur and semiprofessional teams in southwest Washington competed in leagues involving mostly instate teams. Third from right in this 1913 photograph is Wesley Schultz, whose father-in-law was from Dublin. (Courtesy Ed Schultz, Wesley's grandson.)

James D. Ross, whose mother's parents were born in Ireland, was hired in 1902 as superintendent of Seattle's municipal power system, Seattle City Light, and he ran it until he died in 1939. He oversaw the construction of dams that today still supply Seattle with power. In 1930, the Diablo Dam was the tallest in the world, and Ross Lake and Ross Dam are both named for him. (Courtesy C. Bagley.)

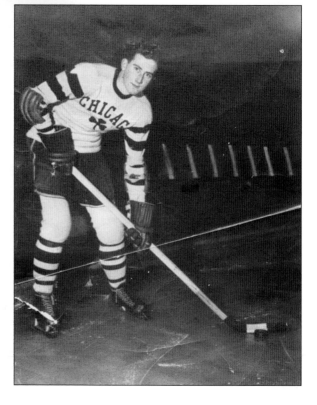

Jack Riley (1910–1994) always claimed he was the first Irish-born professional ice-hockey player. He started his professional career in 1929 with the Seattle Eskimos, later played with the Chicago Shamrocks (right), and then played in the NHL with the Detroit Red Wings, the Montreal Canadiens, and the Boston Bruins. He retired in 1944 in Vancouver, British Columbia. (Courtesy grandson Seán Riley.)

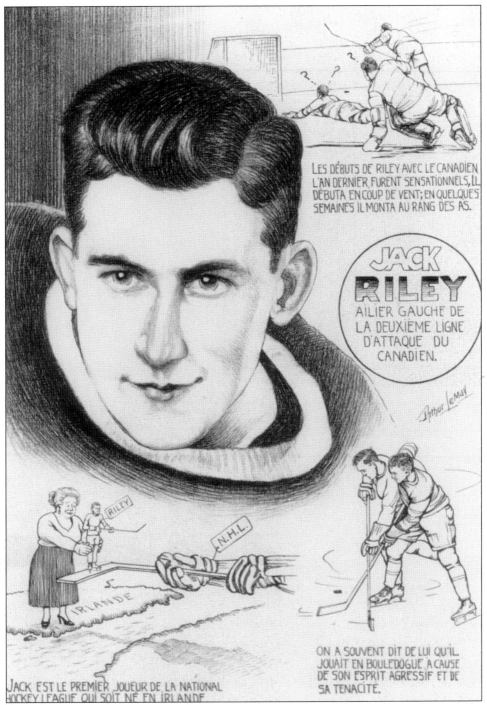

The translation of a French-language Montreal Canadiens poster from 1934 reads: "Riley's debut with the Canadiens last year was sensational. He began like the wind and in a few weeks had moved up the ranks to become a team Ace. Jack Riley—left wing forward for the Canadiens. Jack is the first National Hockey League player to be born in Ireland. It's often been said that he played like a Bulldog, because of his aggressive spirit and tenacity." (Courtesy Seán Riley.)

Harry Lillis "Bing" Crosby (1903–1977), pictured above with his sister Mary Rose, was born in Tacoma to an Irish-American mother, Catherine Harrigan. He dropped out of Gonzaga Law School to become one of the biggest music and movie stars of the mid-20th century. He won an Oscar playing Father O'Malley in the movie *Going My Way* and made the song "Galway Bay" famous. In 1962, Crosby was awarded a Grammy Lifetime Achievement Award. (Courtesy Carolyn Schneider, Mary Rose's daughter and author of *Me and Uncle Bing*.)

Irish-born J. E. Houlihan was one of those arrested on Everett's "Bloody Sunday," November 5, 1916. The Wobblies (Industrial Workers of the World) organized a demonstration in Everett, with many Wobblies coming by boat from Seattle. A drunken, deputized mob met them at the dock, shots were fired, and up to 12 Wobblies and two deputies were killed. Seventy-four Wobblies, many of them Irish, were arrested and charged with murder, but all were released when their leader, Thomas Tracy, was acquitted. (Courtesy Everett Public Library.)

Irish revolutionary leader Eamon de Valera, "Dev," visited Seattle in 1919, and the November 11, 1919, *Seattle P-I* reported that the "Head of So-Called Irish Republic" was greeted by a "Tumultuous Throng." Eight months prior, de Valera had escaped from London's Lincoln Prison using a key baked inside a fruitcake. He came to the United States, including Seattle, Tacoma, and Spokane, to raise funds for the Irish War of Independence. De Valera raised over $5 million, an extraordinary sum in 1919. (Courtesy *Seattle Post-Intelligencer*.)

In 1926, Eamon de Valera founded a new Irish political party, Fianna Fáil, and in 1930, visited Seattle to raise funds for his new newspaper, the *Irish Press*. The photograph below shows de Valera at a typesetting machine in the *Seattle Times* composing room on April 7, 1930. A copy of this photograph was presented to Irish president Mary McAleese on her Seattle visit in 2005. (Courtesy *Seattle Times* Archive. Used with permission.)

DE VALERA GIVEN GREAT RECEPTION

Tumultuous Throng Cheer Themselves Hoarse in His Honor.

ENTHUSIASTS JUBILANT

Sympathizers Overflow Waiting Room Waving American and Irish Flags

HEAD OF SO-CALLED "IRISH REPUBLIC," WHO IS A VISITOR IN SEATTLE TODA

EAMON DE VALERA.

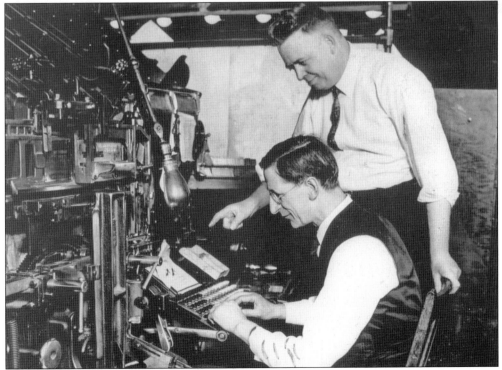

In 1931, a 12-year-old eastern Washington boy was sentenced to life in prison. Pictured at left in 1930, Fr. Edward Flanagan, the Irish-born founder of Boys and Girls Town in Nebraska, started a nationwide campaign to have the boy paroled to him. Flanagan spoke at Seattle's Washington Athletic Club on November 12, 1931, but the governor refused parole, although the boy was released several years later. Flanagan was immortalized by Spencer Tracy in the 1938 movie *Boys Town*. (Courtesy Girls and Boys Town.)

Pictured below during the Depression, Seattle mayor John F. Dore addresses thousands of unemployed in City Hall Park. Dore was a Boston-born lawyer of Irish extraction who served two terms as Democratic mayor, 1932–1934 and 1936–1938. Allied with the unions and the unemployed, he frequently butted heads with a Republican city council. He died in 1938 before completing his second term. (Courtesy UW Digital Collections, LEE-20121.)

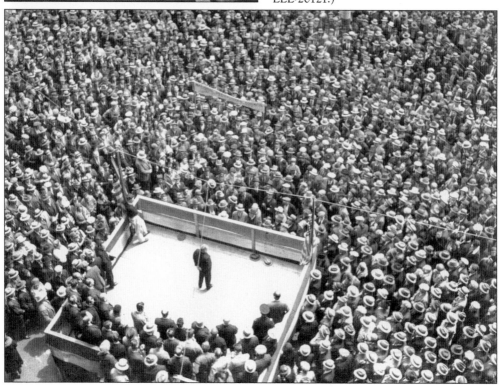

Three

EARLY IRISH FAMILIES

The first non-native settlers in present-day Washington state were Michael T. Simmons and his good friend George W. Bush, both of whom settled near Olympia in 1844 and both of whom had Irish ancestors. They came north because, although Bush's mother was Irish-American, his father was African American, and at that time, Oregon's racial-exclusion laws did not permit him to settle south of the Columbia River.

Irish immigrant Samuel Benn was the first settler and leading citizen of Aberdeen. Irish-born Teresa Lappin, who married Capt. Edward Eldridge, was the first white woman on Bellingham Bay and was called the "Mother of Whatcom." The town of Cathcart was named for Isaac Cathcart from County Fermanagh, and the town of Ireland in Clark County was so named because of the number of Irish farmers there. The town of O'Brien, now part of Kent, was founded in 1869 by brothers Terence and Morgan O'Brien, and a colony of Irish settled and farmed the area.

Many other towns and localities in Washington also were named by and for Irish people, including McDonald, McCormick, McCleary, Buckley, Connell, McGuire, McNelly, Logan, Galvin, Flynn, Reynolds, Foran, and Donahue. With amalgamation into nearby cities, many such towns have disappeared, but the Irish who lived and worked in the state in the early days left an indelible imprint.

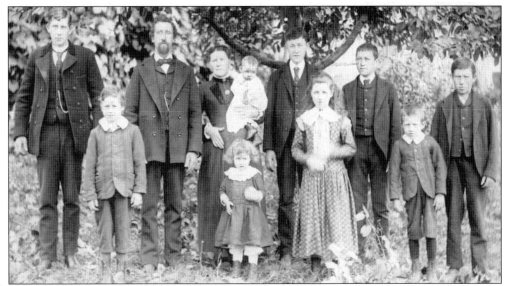

Michael Donlon and Anne Murray were born in Ireland and met and married in New York. They came to Issaquah in 1879 and started farming. The first Catholic Mass in Issaquah was in their home in 1883. In 1891, Donlan donated land, and P. J. Maloney provided the labor to build Issaquah's St. Joseph's Catholic Church, which was completed in 1896. Above in 1888 are, from left to right, the Donlans with (first row) Mamie, Anne Catherine, and George; (second row) John, William, Michael, Anne holding Rose, Peter, Joe, and Mike. Anne Catherine later married P. J. Maloney. (Courtesy Shawn Fitzpatrick.)

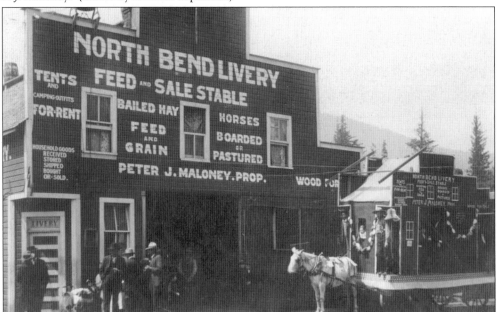

Pictured above is P. J. Maloney's livery stable with a horse-drawn Fourth of July float parked in front. Born in 1865, son of Patrick Maloney from County Limerick, P. J. came to Seattle in 1888 and moved east to the Snoqualmie Valley, where he was a carpenter, saloon keeper, and livery-stable owner. Until 1939, he also owned and operated Maloney's Grove, a popular automobile camp at the foot of the Cascades. (Courtesy Shawn Fitzpatrick.)

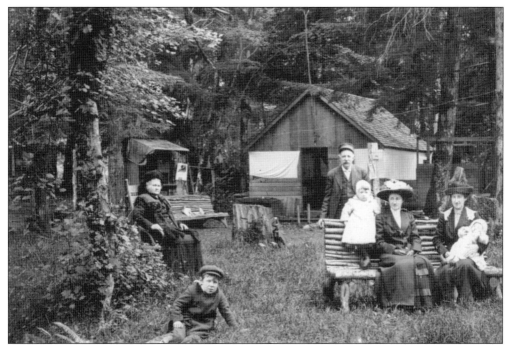

"Sleepy Den," pictured above in 1908, was the first cabin at Maloney's Grove near North Bend. Pictured from left to right are Anne Murray Donlan (P. J. Maloney's mother-in-law), Aubrey Maloney (foreground), P. J. Maloney, Pete Maloney Jr., Annie Maloney (P. J.'s wife), and Mamie Donlan O'Connor with her daughter Annie. (Courtesy Shawn Fitzpatrick.)

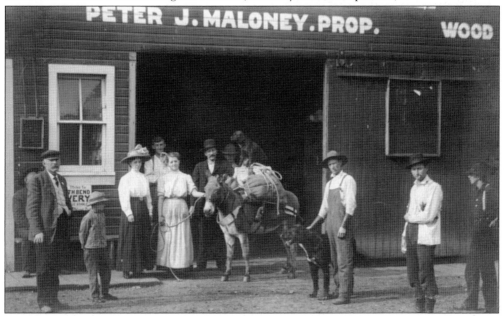

At Maloney's Livery Stable, one could rent or buy camping provisions and also rent a horse or burro (like the one pictured above) to carry them. Maloney, the first white man to cross Snoqualmie Pass on horseback and the first mayor of North Bend, was a cousin of John Maloney in Skykomish. Maloney died in 1942. (Courtesy Shawn Fitzpatrick.)

When the railroad through the Cascades was built in 1892, trains switched from steam engines to electric at Maloney's Siding. Now named Skykomish, the original name came from John Maloney, whose parents were born in Ireland. He owned the general store (pictured above left in 1913) and was the town's first mayor. Patrick McEvoy from County Kerry was the engineer on the first scheduled train through the Cascades. McEvoy later opened a saloon in Skykomish that still exists today, as does Maloney's original store. (Courtesy UW Digital Collections, PICKETT-1723.)

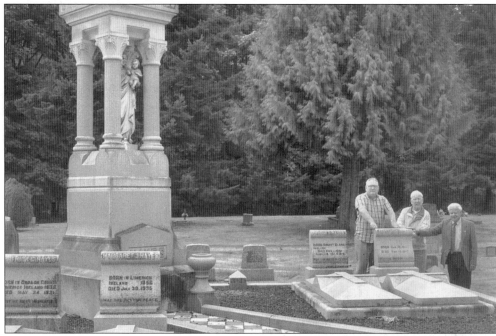

In 1880, Richard and Sarah O'Connell set aside four acres on their family farm near O'Brien to be used as a cemetery for themselves and other Irish families. In 1902, they formally transferred St. Patrick Cemetery to the Nesqually (now Seattle) Diocese for $1. Pictured above, Paul McCarthy from County Tipperary, Jim Foskin from County Kilkenny, and Finian Rowland from County Mayo examine the Hayes family plot at St. Patrick, which is located just off Interstate 5 at Orilla Road and South 204th Street, in Kent.

Patrick Hayes (1832–1921) from County Limerick was a miner, gold prospector, and logger before coming in 1860 to the White River Valley area south of Seattle, later named O'Brien. In 1867, he married Bridget Burns (1846–1881) from County Clare, and they had seven children. After Bridget's death at the age of 35, Patrick married Margaret Mick (1856–1935) from County Limerick (pictured below). From 1876 until 1892, Hayes was one of the Seattle area's largest hops farmers and regularly employed hundreds of hops pickers. In 1909, he donated 100 acres for Briscoe Memorial School for Boys, operated by the Irish Christian Brothers. (Both photographs courtesy John Costello.)

Dear Father Mother Sister and Brothers,

I once more take the opportunity of addressing ye a few lines from the far and distant shores of Puget Sound. It's often l think of ye & Cousins & Uncle and all my old Companions. To speak in truth, my last thought going to bed at night and first arising in the morning are of home. The thoughts of it everlastingly haunts my mind.

............... But then I still think I am in as good a country as there is in the world today for a poor man. The majority of what men is in the country have risen from their own industery. Any man here that will work and save his earnings, and make use of his brains can grow rich.

.........and sooner than I would work for a farmer in Ireland, I would cut off my good right hand. I don't think little of Ireland by talking so, for its the dearest spot upon the earth to me.
<div style="text-align:center">

For as true as the needle by magnet love lead
My sad heart points faithfully back to old Ireland
In vain all the charms of creation may woo
While away from thy shores,
Oh, my sweet sainted sire land
</div>

There is one thing certain if they ever do come out here. For many a long month they will wish they stopped at home. But home sickness is something that's natural. I often get a relapse of it but somehow there seems to be no cure only to stand it. I often thinks that I would give $200 for to be at home again for the short space of one day. But when you cannot have what you like, you must learn to like what you have.

Wages is good, work and Land plenty but a wild looking Country, all woods, trees: Some of them I have seen 14 and 15 feet in diameter. If that was in Croagh the people would class it one of the seven wonders of the world.

Let me know how times are in Ireland. They will hang ye all before ye leave there I think......

The only dislike I have is the hours are so long. In the morning now I do be up and have 50 head of cattle, pair of horses fed 6 cows milked and breakfast and then it is not day. Often I sits down and think of everybody I wished well to home. Indeed I do be thinking of ye when ye don't least expect it. I felt kind of forlorn all last summer.

When Sunday comes takes a rifle or shotgun, go out to hunting. Wild animals of all description abound here. And as for wild ducks they are as thick as the cows to home. Also pheasants & grouse & you can take your gun, or four if you want to, and nobody will ask where is your license. All you want is money enough to buy a gun. To sum all up this is a free Country.

I must conclude by wishing ye & Cousin & Uncle a fond adieu.

Respectfully yours

J F Costello

John F. Costello (1860–1929) was born in County Limerick, and in 1880, came to Seattle to join his uncle Pat Hayes. In 1885, Costello married Bridget Costello (no relation), who left County Limerick in 1884, and they raised 11 children. After clearing trees and brush, the Costellos farmed 40 acres, raising hay and potatoes and operating a dairy. Bridget died in 1922 and is buried beside John in St. Patrick Cemetery. In 1883, Costello wrote a letter to his family in Croagh, County Limerick. Parts of the letter are transcribed above exactly as Costello wrote them. (Courtesy Costello's grandsons, John and Leo Costello.)

The two boys in back on right on the O'Brien School baseball team in 1907 are Lawrence and Patrick Costello, sons of John F. Costello from County Limerick. Patrick joined the U.S. Army and saw action in Europe in World War I and later worked his own dairy farm. Lawrence also was a dairy farmer and served as a Republican state representative in Olympia from 1947 to 1949. The O'Brien School was replaced in 1990 by the new Neely O'Brien Elementary School. (Courtesy White River Valley Museum, No. 964.)

In 1980, several descendants of John F. Costello attended a St. Patrick's Day party at the governor's mansion in Olympia. Pictured from left to right are Gov. John and Lois Spellman, with the Costellos: Johnny, Carol (Leo's wife), Leo, John, Eileen, and Mary Jo (John's wife). John and Leo Costello are grandsons of John F. Costello, while Johnny and Eileen are his great-grandchildren. (Courtesy Leo Costello.)

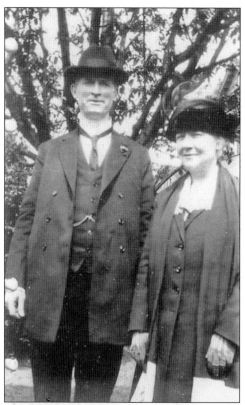

John Harnan (1864–1931), born in Pennsylvania of Irish parents, and Catherine Hogan (1872–1927), born in Illinois of Irish parents, married in 1900. After prospecting in Colorado, they moved to Seattle and raised seven daughters on Capitol Hill, three of whom became Notre Dame Sisters. The Harnans, pictured here in the 1920s, helped build St. Joseph's Church and donated the church's Stations of the Cross. In 1940, their daughter Dorothea married John T. Dalton, seen below. (Courtesy Marcia Dalton.)

The Dalton family is pictured here in 1930 with Matthew (center), surrounded by Grace, Bradley, John T., and Mary. Matthew was born in Canada in 1876 and was of Irish descent. He became a surgeon and started Dalton Hospital in Sumas on the Canadian border, operating it from 1907 until he sold it in 1920. He went into private practice in Seattle and became chief of staff at Columbus (later Cabrini) Hospital. He was also a member of the Friendly Sons. (Courtesy Marcia Dalton.)

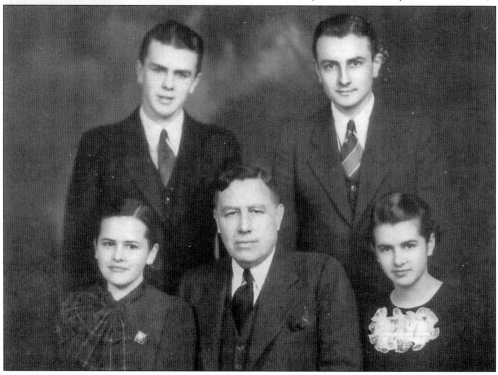

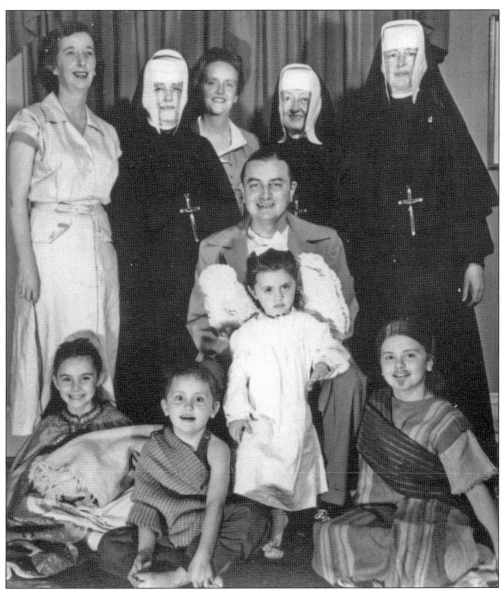

Posing for their 1949 Christmas family photograph are the Daltons and Harmons. Seated are the Dalton children, from left to right, Janet, Denice, Marcia, and Diane while John T. Dalton is in the center. Standing are the Harnan sisters, from left to right, Natia Harnan, Sr. Loyola Mary (Mary Harnan), Dorothea Dalton (pregnant with John T. Jr.), Sr. Ignatia Maria (Margaret Harnan), and Sr. Aloysia Maria (Cecilia Harnan). John T. Dalton (1909–1988) was an attorney in Seattle and donated the altar in St. Joseph's Catholic Church on Capitol Hill. In 1955, John T. served as president of the Friendly Sons. In 1963, he started the Pioneer Fellowship House, which is devoted to the recovery and rehabilitation of male alcoholics. In its 43-year history, the program has served over 100,000 individuals on the margins of society. (Courtesy Marcia Dalton.)

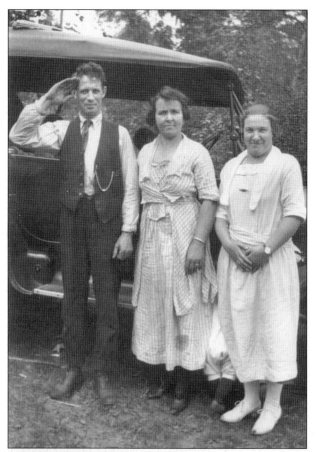

Shown at left are Patrick and Margaret Moriarty with Lily Kempson, and shown below are Matt McAlerny and Patrick Moriarty. Both photographs were taken at an Irish picnic at Seattle's Echo Lake in 1919. The Moriartys left County Cork in 1911 and, after meeting in Butte, came to Seattle, where they married in 1912 and where Pat operated a coal yard at Twenty-Eighth and Jackson. Margaret died in 1961 and Pat in 1969. Kempson came from Dublin in 1916, while McAlerney had just recently arrived in Seattle from County Donegal. Kempson and McAlerney later married and together raised seven children. Matt died in 1981, and Lily in 1996. The 1912 touring car in the photographs was owned by Moriarty and was used later that year to transport Eamon de Valera during his visit to Seattle. (Both photographs courtesy Kevin Moriarty.)

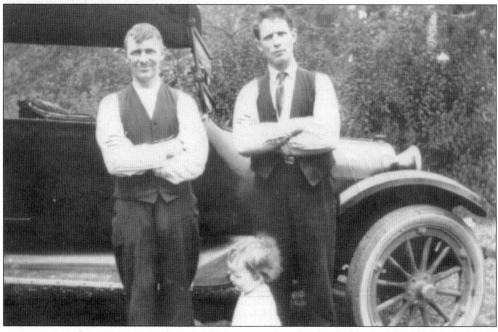

Born in Dublin, Elizabeth "Lily" Kempson (1897–1996) was a member of James Connolly's Irish Citizen Army and is pictured at right in her uniform in 1914. During the 1916 Easter Rebellion, Kempson provided support and was a courier for the rebels holed up in Dublin's General Post Office. When the rebellion collapsed, Kempson came to Seattle. The Irish government later awarded her a pension for her part in Ireland's War of Independence. (Courtesy Kevin Moriarty.)

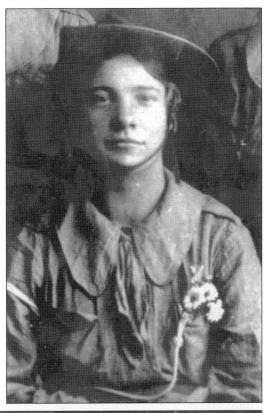

In 1882, Irish-born Patrick (1826–1907) and Virginia Downey homesteaded a 160-acre farm in present-day Clyde Hill, near Bellevue. They raised strawberries that were brought to Seattle via wood-burning steamers across Lake Washington to Leschi, and via cable car from there. Mass was celebrated in the Downey family parlor until 1913, when a small wooden church was built in Bellevue. Pictured below in 1921 are the Downeys with their 13 children. (Courtesy Eastside Heritage Center.)

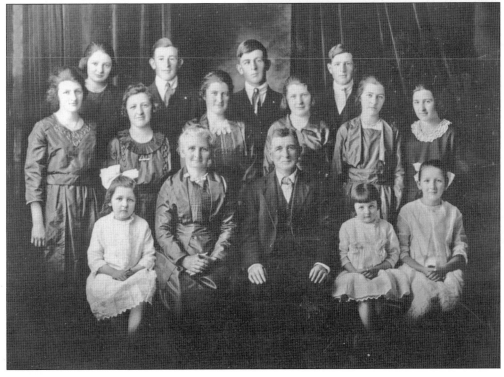

THE QUEEN OF ALASKA

Title Earned by a Seattle Woman on the Yukon.

NOW OWNER OF GOLD NUGGETS

3 Sept. 1896

How Bridget Manion Found Wealth and a Husband in the Icy North—A Visitor to the City.

Sept 3 1896

A queen has been visiting Seattle for several days past and few persons have been aware of the fact. Not a real crowned queen, ruler of nations, or one who has a court filled with brilliantly dressed subjects, but the woman who has sprung into local fame as "The Queen of Alaska." She is Mrs. Aylward, of Napoleon gulch, eighty-five miles from Forty-mile creek.

Born in County Galway, Bridget Manion (1866–1935) became housekeeper to Seattle pioneer Henry Yesler in 1889. In 1892, she traveled to Alaska and worked as housekeeper at a Yukon River trading post. She said later that as a rare, single, non-native woman in the Klondike, she received "152 proposals of marriage" in her first six months there, and in 1894, she married Frank Aylward, a successful prospector from County Kerry. While visiting Seattle on her way to Ireland in 1896, a Seattle newspaper called her "Queen of Alaska." The Aylwards later retired to Seattle and lived on Capitol Hill. After Frank died in 1913, Bridget frequently visited Ireland and on her 1919 trip, brought her niece Mary Keane back from Galway. Pictured below are Bridget and Mary in 1921. A niece of Frank Aylward, Nellie Cullen, also came in 1923 from County Kilkenny. In 1925, the "Queen of Alaska" moved permanently to Galway where she died in 1935. (Courtesy Kathleen Donahue.)

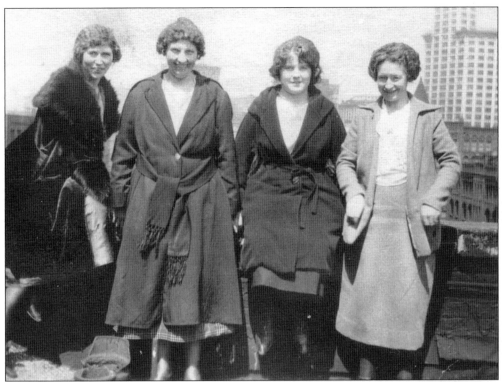

In 1922, Mary Keane (second from right) poses with coworkers on the roof of the building where they worked. Note in the background the Smith Tower, built in 1914 and the tallest building on the West Coast until the Space Needle was built in 1962. Keane (1899–1994) later married Dubliner Pat Tomkins (1899–1980) in Seattle in 1928. They raised seven children on Capitol Hill near St. Joseph's, where their home was a center of Irish activities. (Courtesy Kathleen Donahue.)

Born in Dublin, Pat Tomkins (1899–1980) came to Chicago when orphaned in 1916 but returned to Ireland in 1917. He is pictured at right, leaving for Ireland. In 1921, he came to Seattle and, in 1928, married Mary Keane. In the 1920s and 1930s, Tomkins was president of Seattle's chapter of the American Association for Recognition of the Irish Republic, an organization founded by Eamon de Valera to help organize his 1919–1920 U.S. tour. (Courtesy Kathleen Donahue.)

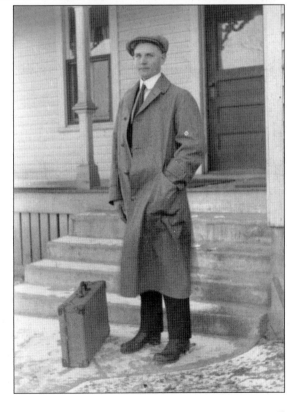

Bridget Aylward (right), pictured above around 1900, visits with her cousins, James and Katherine Hatchell, who were from Ireland, outside their home on Denny Hill. Their home was demolished as part of the 1900–1910 construction project that removed Denny Hill and created Harbor Island in Elliot Bay. (Courtesy Kathleen Donahue.)

In 1923, Nellie Cullen (1907–2000) came from County Kilkenny to Seattle to join her aunt (by marriage) Bridget Aylward. Cullen was only 16 when she traveled alone by boat to New York and from there by train to Seattle. The following year, she met Mike Nolan (d. 1979) from County Carlow, who had just arrived in Seattle. They married in 1925 and had six children. Pictured here are Nellie and Mike Nolan in the 1940s. (Courtesy Eileen Pat Dunn.)

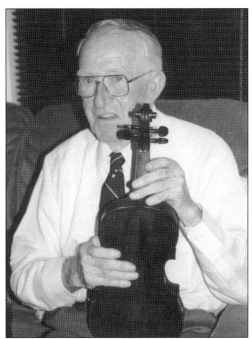

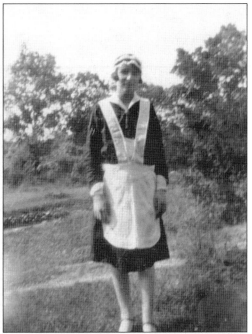

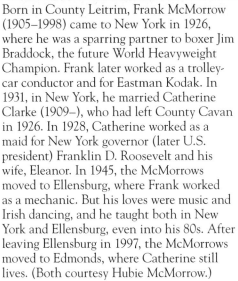

Born in County Leitrim, Frank McMorrow (1905–1998) came to New York in 1926, where he was a sparring partner to boxer Jim Braddock, the future World Heavyweight Champion. Frank later worked as a trolley-car conductor and for Eastman Kodak. In 1931, in New York, he married Catherine Clarke (1909–), who had left County Cavan in 1926. In 1928, Catherine worked as a maid for New York governor (later U.S. president) Franklin D. Roosevelt and his wife, Eleanor. In 1945, the McMorrows moved to Ellensburg, where Frank worked as a mechanic. But his loves were music and Irish dancing, and he taught both in New York and Ellensburg, even into his 80s. After leaving Ellensburg in 1997, the McMorrows moved to Edmonds, where Catherine still lives. (Both courtesy Hubie McMorrow.)

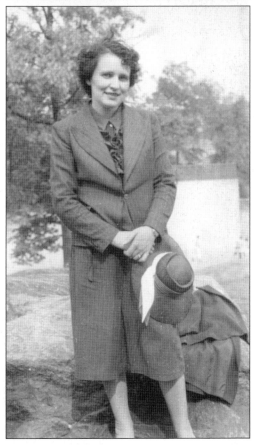

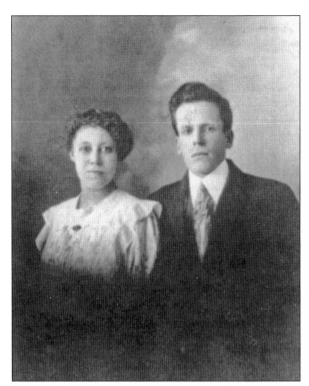

Jack and Frances McCoy pose after their 1916 wedding. Born in Dublin in 1883, McCoy was a restaurateur in the 1920s and a rancher in the 1930s but lost everything during the Depression, and he became a laborer in Yakima. Heavily depressed, McCoy disappeared in 1957, and a body was later found and identified as him. Two months after the funeral, McCoy turned up at his daughter's house in Seattle and reconnected with his family. Even today, the man buried in McCoy's place remains unidentified. Kevin Moriarty's play *A Rose for Danny* is about his grandfather McCoy, who died in 1963. (Courtesy Kevin Moriarty.)

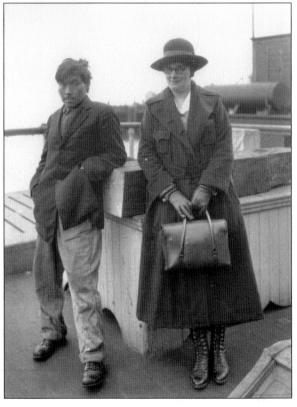

Irish-born Elizabeth Brady was a member of the Providence School of Nursing's first graduating class. In 1924, she worked as a Red Cross nurse for the city of Seattle and later worked as a nurse in the Seattle Public Schools. In the photograph here, Brady visits with one of her homeless clients. (Courtesy MOHAI, 83.10.202.)

Four

FAITH AND COMMUNITY

Most of the Irish who came to the United States in the late 1700s were non-Catholic, mainly Presbyterians from the north of Ireland. Irish Catholics started immigrating in large numbers in the early 1800s, but after the Great Irish Famine, 1845–1852, there was a huge tide of Irish Catholic immigrants into the United States. By the end of the 1900s, more than half of all Catholic priests and nuns in the United States were of Irish birth or ancestry, leading to the terms "Irish" and "Catholic" becoming almost synonymous.

In the mid-1900s, Irish-born priests in Seattle were as common as Irish police officers in other cities. The growth of the Catholic Church here far outstripped the local supply of priests, and during the 1950s, three or four priests from Ireland arrived annually. The flow of priests from Ireland dried up in the 1970s, and the last newly ordained Irish-born priest to come to Seattle was Fr. John Madigan, who arrived in 1974.

Recruitment of women in Ireland to join religious orders of sisters in the Pacific Northwest was also common, even in the early 1900s, and the Tacoma Dominicans, the Edmonds Dominicans, and the Sisters of St. Joseph of Peace still have many sisters in their communities who left Ireland in the 1950s and later.

These Irish-born priests and nuns were very important to Seattle's Irish community, serving as focal points by helping with weddings, baptisms, and funerals; arranging jobs, references, and schools; and providing counseling and other assistance when needed.

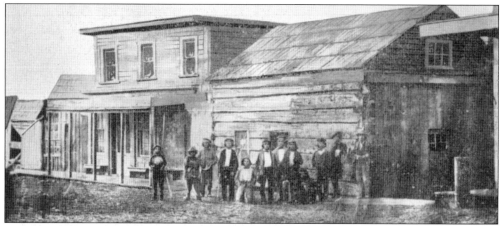

Yesler's sawmill cookhouse, pictured above in the 1860s, also served as courthouse, jail, hotel, and church. Seattle's first organized Christian service was held there in 1852, when Fr. Modeste Demers celebrated Catholic Mass on an altar prepared by the non-Catholic Arthur Denny and by Chief Seattle, who was Catholic. Among the languages used were Latin for the Mass, Demers's French, Chief Seattle's Salish, English by the mostly Protestant attendees, and probably Gaelic by at least one Irishman attending. (Courtesy C. Bagley.)

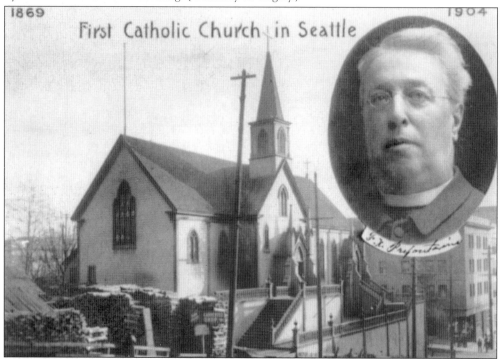

In 1864, Fr. Francis Xavier Prefontaine became Seattle's first assigned Catholic priest, but his first visit to Seattle wasn't until 1867. Seattle had about 600 inhabitants at the time, amongst whom he found 10 Catholics, but only three showed up for his first Mass! He built Our Lady of Good Help, pictured above, and many other parishes and churches before dying in Seattle in 1909. His name graces a Seattle building, street, park, and fountain—all near Third and Yesler. Our Lady of Good Help Church was demolished in 1905. (Courtesy Archives of the Catholic Archdiocese of Seattle.)

Edward O'Dea (1856–1932) was born in Massachusetts of Irish immigrant parents. In 1896, he became Bishop of the Diocese of Nesqually, then covering all of Washington. He traveled the length and breadth of the state, much of it on horseback and by boat. He led his flock through financial difficulties and KKK-fanned anti-Catholic bias, and supported the work of Mother (now Saint) Frances Cabrini. He died on Christmas Day, 1932. (Courtesy C. Bagley.)

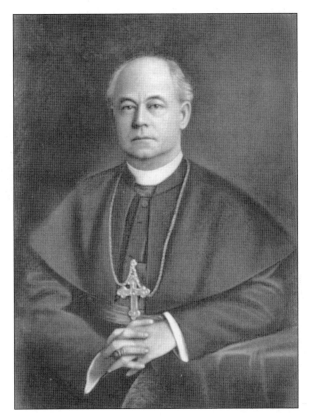

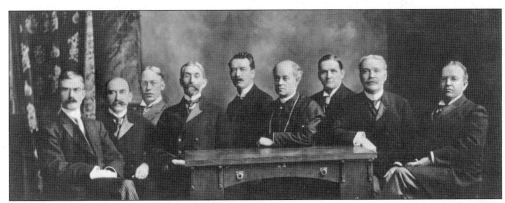

In 1904, Bishop O'Dea moved the See of the Diocese from Vancouver to Seattle, and in 1907, built a new cathedral, St. James. The Cathedral Building Committee, pictured above, included some of Seattle's most prominent businessmen, almost all of whom had Irish connections through ancestry or marriage. Pictured from left to right are George Donworth, J. A. Baillargeon, Philip Kelly, J. D. Farrell, J. P. Agnew, Bishop O'Dea, William Pigott, John B. Agen, and Daniel Kelleher. (Courtesy PACCAR.)

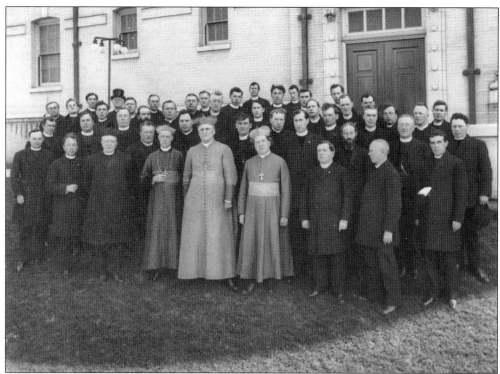

Bishop O'Dea poses with his priests in 1914, many of them Irish. The first recorded Irish-born priest in the state was Fr. Michael King from County Offaly, ordained in 1853 at Dublin's All Hallows College for the "Diocese of Nesqualy, Oregon," and who served at the cathedral in Vancouver. Most of Seattle's Catholic bishops and archbishops throughout the 1900s have had Irish ancestry, including today's Archbishop Alexander Brunett. (Courtesy UW Digital Collections, A.CURTIS-10205.)

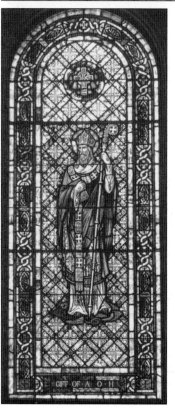

The stained-glass window of St. Patrick by Charles Connick (1917–1918) in St. James Cathedral in Seattle was donated by the Ancient Order of Hibernians (AOH). Seattle's AOH was at the forefront in supporting church activities and in combating anti-Catholic bias in society in the early 1900s. (Courtesy St. James Cathedral.)

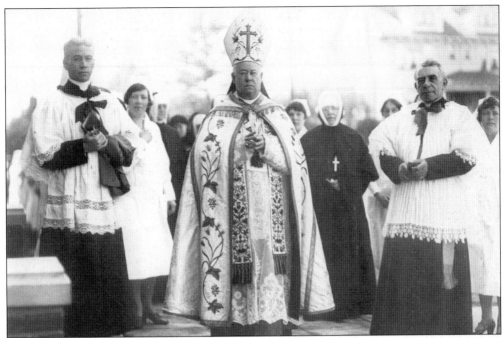

In 1914, Msgr. Theodore Ryan, shown above left in the 1930s with Bishop O'Dea, was the first native Seattleite to be ordained a priest. His parents were from County Tipperary, and his contractor father built Seattle's Knights of Columbus Hall, Immaculate Conception School, and the priest's house. Monsignor Ryan served as secretary to the bishop and diocesan chancellor and was a first cousin once removed of the current pastor at St. James Cathedral, Fr. Michael G. Ryan. (Courtesy St. James Cathedral.)

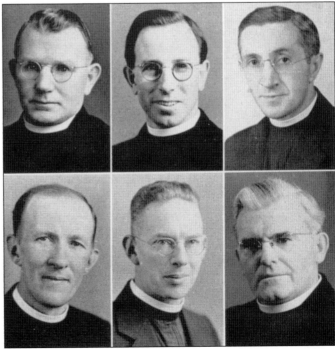

O'Dea High School, Seattle's last all-male Catholic high school, boasts the nickname "The Fighting Irish" and is run by the Congregation of Christian Brothers, an order founded in 19th-century Ireland to educate primarily the children of the poor. O'Dea opened in 1925 and today has a 475-member student body that is 38 percent minority. Pictured here are, clockwise from the top left, Brothers O'Dwyer, Power, Fitzgerald, Walsh, Hunt, and Kelly—all Irish Christian Brothers who taught at O'Dea High School in 1936. (Courtesy O'Dea High School.)

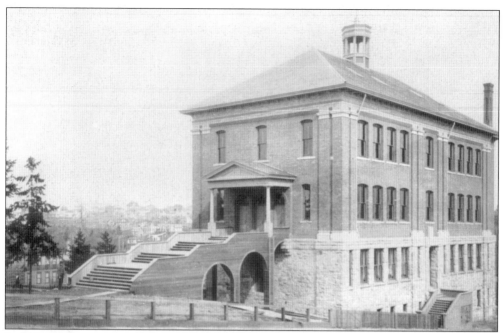

In 1890, the Jesuits paid Arthur Denny $18,382 for land at Broadway and Madison and started Immaculate Conception Church and School, which became Seattle College in 1898 and Seattle University (SU) in 1948. The college, pictured above in 1931, secured full university accreditation in 1936, and SU is now the largest independent educational institution in the Pacific Northwest, with over 7,000 students in attendance. (Courtesy Seattle University.)

From 1898, Seattle College offered both college and high school classes at the corner of Broadway and Madison, but it was cramped for space. Thomas C. McHugh, pictured left in 1900, was a wealthy businessman and the grandson of Irish immigrants, who, in 1919, donated land and buildings on Interlaken Boulevard to the school, which promptly moved to the site. In 1931, Seattle College moved back to Broadway, but the high school remained on Interlaken and today is called Seattle Prep. (Courtesy Mick McHugh.)

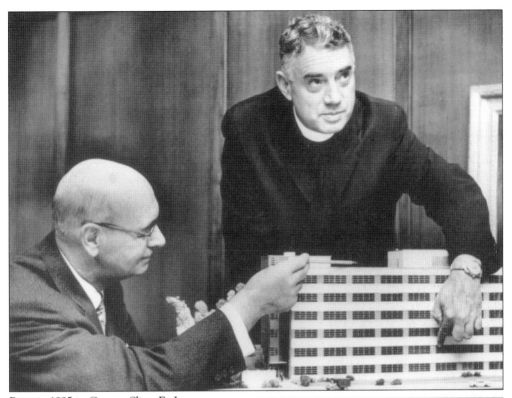

Born in 1895 in County Sligo, Fr. James McGoldrick, S. J. (1895–1983), shown above right in 1970, came to all-male Seattle College in 1931. He immediately introduced coeducational "night school" classes starting at noon. When Bishop Shaughnessy complained, McGoldrick explained he didn't want "to have to dismiss the boys!" Jesuit Superiors in Rome accepted the situation as being necessary to maintain the student population required for university accreditation. Several scholarships and fellowships carry McGoldrick's name at SU. (Courtesy Seattle University.)

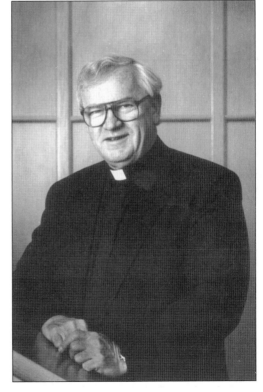

William J. Sullivan, S. J., was SU's 20th president and served from 1976 to 1996, during which time SU became one of America's top regional colleges. Under his leadership, SU's endowment grew from $4 million to $90 million and enrollment from 3,400 to 6,000, and SU got a new law school. Sullivan welcomed the Dalai Lama onto campus, chaired the 1990 Goodwill Games, and married Bill and Melinda Gates. In 1987, the *Seattle Times* named him one of Seattle's most powerful community leaders. (Courtesy Seattle University.)

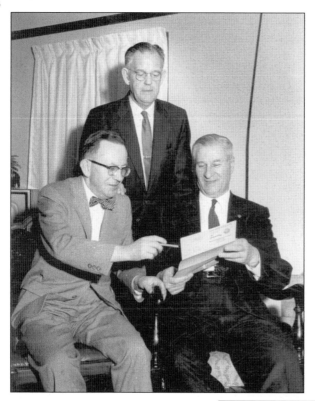

In 1935, in Seattle, Irishman Dan Rooney (standing), with Richard Ward (seated, left) and Harold Haberle, founded the Serra Club, a Catholic organization that promotes vocations to the priesthood and religious life and is named for Blessed Junipero Serra. Today Serra has more than 800 clubs in 37 countries and over 19,000 members, about 230 of whom are in the Seattle area. (Courtesy of Al Giordano.)

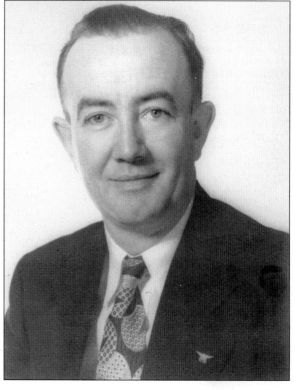

Louis "Pat" Campbell fed thousands though Feed-In, the St. Vincent de Paul Society program he ran at Blessed Sacrament Church. In 1973, he helped start Genesis House, a treatment home for heroin addicts. In 1985, he received a Jefferson Award, a program honoring ordinary people who do extraordinary things. He was 83 when he died, on March 10, 1999, and to honor his Irish heritage, the family delayed his funeral until St. Patrick's Day and asked everyone to wear green. (Courtesy Pat and Renee Campbell.)

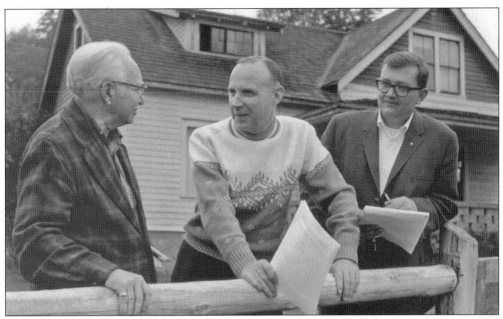

Fr. William Treacy came to Seattle from County Laois in 1944. He is best known for the hugely popular interfaith television program *Challenge*, which aired on KOMO-TV from 1960 to 1974. Treacy and Rabbi Raphael Levine were permanent panelists, along with a rotating Protestant minister. In 1967, Treacy and Levine founded Camp Brotherhood to foster harmony among different faiths and races. Pictured in 1968 at Camp Brotherhood are, from left to right, Levine, Treacy, and Rev. Wilfred Burton. (Courtesy MOHAI, *Seattle Post-Intelligencer* Collection, 86.5.32.996.1.)

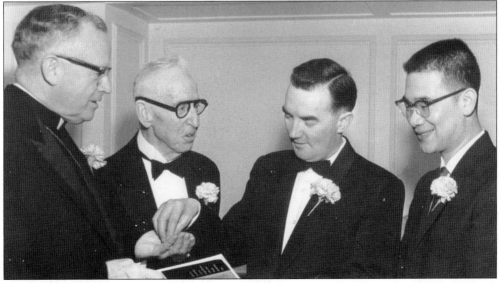

Archbishop Thomas Connolly, Friendly Sons president emeritus Pat Barry, tenor Bob McGrath and Councilman Wing Luke are pictured here at the 1963 Friendly Sons banquet. The son of parents from County Monaghan, Connolly headed the Archdiocese of Seattle from 1948 until retirement in 1975. He established 43 new Catholic parishes, oversaw the construction of more than 350 churches and schools, and was an outspoken advocate for civil rights. He was the oldest Catholic bishop in the United States when he died in 1991 at age 91. (Courtesy FOSP.)

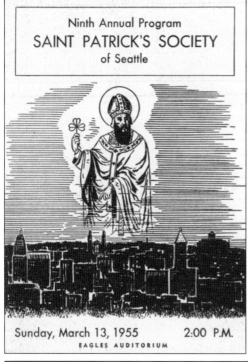

Ninth Annual Program
SAINT PATRICK'S SOCIETY
of Seattle

Sunday, March 13, 1955 2:00 P.M.
EAGLES AUDITORIUM

In the late 1940s and 1950s, the St. Patrick's Society of Seattle promoted Irish music with a St. Patrick's Day concert involving performances from high schools of the Catholic archdiocese. On the program cover pictured at left, note the Seattle skyline with the 522-foot-tall Smith Tower on the right and, in the center, the twin spires of St. James Cathedral. (Courtesy FOSP.)

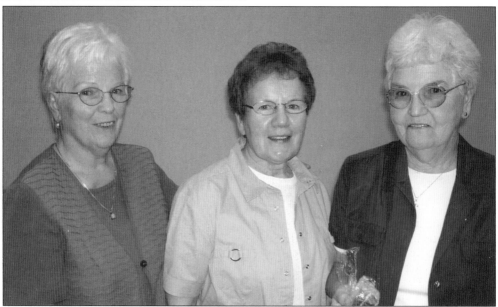

Growing up sisters in County Cork, Mary Pat, Peg, and Nora Murphy, pictured above from left to right, also became religious sisters, joining the Tacoma Dominicans religious community. Sisters Mary Pat and Nora came to Tacoma in 1952, and Peg joined them in 1958. They have worked as teachers, nurses, and administrators at hospitals, churches, and social-service agencies in Washington, Oregon, and California. In 2005, Sister Peg received the Archbishop Hunthausen Humanitarian Award as founder of Catherine Place, a Tacoma-based outreach center for homeless women. (Courtesy Tacoma Dominicans.)

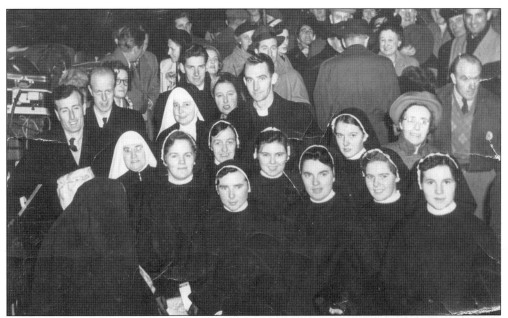

In 1951, nuns and postulants wait in Cobh, County Cork, to board a ship for America as others wait to see them off. Among those in the photograph who came to Tacoma in 1951 or 1952 are, from left to right, (first row) Bridget Reilly from County Galway, Maureen Ridge from County Galway, Marie Celine McMahon from County Leitrim, and Nora Murphy from County Cork; (second row) Sr. Mary Clara from County Cork, Mary Pat Murphy from County Limerick, Carmel O'Farrell from County Roscommon, Bridget Reid from Dublin, and Camilla McMahon from County Leitrim. The sister in the back is Mary Salesia from County Meath. (Courtesy Tacoma Dominicans.)

In 1957, four 16- and 17-year-old Irish girls were students at Tacoma's Aquinas Academy as postulants with the Tacoma Dominicans. Pictured here from left to right are (first row) Mary Keating from County Carlow and Brigid O'Malley from County Galway; (second row) Ann McGrath from County Dublin and Cathy Duffy from County Westmeath. (Courtesy Mary Shriane.)

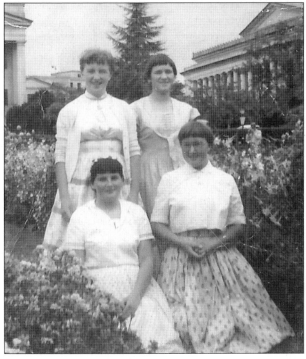

Seattle's Gaelic Club members pose at St. James Cathedral following their 1958 communion breakfast. The two priests in the middle are Fr. Dan Lyons, S. J., and Fr. William Treacy. (Courtesy Finian Rowland.)

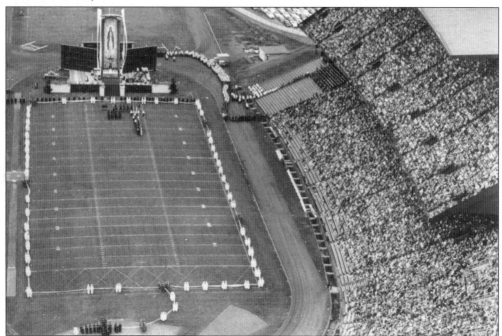

On October 21, 1956, some 50,000 people attended the Family Rosary Crusade Rally, led by Fr. Patrick Peyton at the UW's Husky Stadium. Known as the "Rosary Priest," Peyton was born in 1909 in County Mayo, and his crusade slogan, "The family that prays together stays together!" was known worldwide. (Courtesy Archives of the Catholic Archdiocese of Seattle.)

On May 14, 1962, Mother's Day, 75-year-old Mary Treacy from County Laois was named the Seattle World's Fair Mother of the Year. Mary was brought from Ireland by the Seattle Council of the Knights of Columbus as a surprise for her son, Fr. William Treacy. The 1962 Seattle World's Fair attracted almost 10 million visitors from around the world, including Dublin's first-ever Jewish lord mayor, Robert Briscoe. (Courtesy Jim Leo and *The Herald*.)

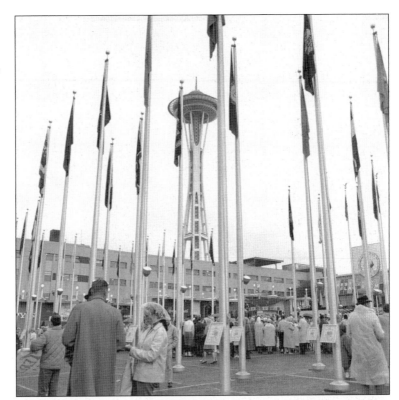

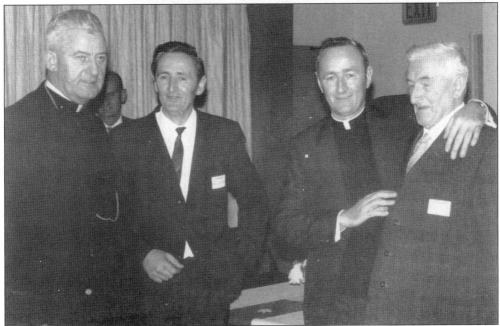

Pictured from left to right in 1970, Seattle archbishop Thomas Connolly visits with Terry Gallagher, his brother Father Brendan, and their father, John. Brendan came to Seattle in 1952, and his parishioners in Tacoma surprised him by bringing his father and brother to visit from Achill Island, County Mayo. (Courtesy Brendan Gallagher.)

Rev. Barry Keating, pictured here with his wife, Nancy, was born in 1952 in Belfast, became a Presbyterian minister, and was pastor at a church in Belfast. He came to Seattle in 1987 and has been a leader in Seattle's Irish community, including serving as president of Seattle's Irish Heritage Club. Now a Presbyterian pastor in Edmonds, he helps organize Seattle's annual St. Patrick's Day Catholic Mass for Peace in Ireland at Plymouth Congregational Church. (Courtesy Barry Keating.)

Seattle archbishop Thomas Murphy and Anglican priest Rev. Trevor Williams, director of Northern Ireland's Corrymeela Reconciliation Community, marched together in Seattle's 1996 St. Patrick's Day Parade. Murphy (1932–1997) was born in Chicago of Gaelic-speaking parents from County Kerry. He came to Seattle in 1987 and was very popular in Seattle's Irish community. Asked if he knew any Gaelic, he replied, "A few words, but nothing a bishop should repeat!" Murphy died of leukemia in 1997. Williams spoke at the 1996 St. Patrick's Day Mass. (Courtesy Barry Keating.)

Five

THE AOH AND THE FRIENDLY SONS

The Ancient Order of Hibernians (AOH) is a fraternal organization whose members are males of Irish extraction who are practicing Catholics, and its motto is "Friendship, Unity, and Christian Charity." The AOH started in the United States in 1836 and the AOH Ladies Auxiliary, the female branch, was established in 1894. The AOH came to Washington Territory in 1889 and soon had branches in Seattle and five other Washington cities. Later an AOH Ladies Auxiliary was started. While Seattle's Ladies Auxiliary lasted until the 1950s, all local AOH chapters seem to have disappeared by the 1940s.

The Society of the Friendly Sons of St. Patrick was founded in Philadelphia on March 17, 1771. At its first meeting were George Washington's Irish-born aide-de-camp, Gen. Stephen Moylan, and John Dickenson and Robert Morris, who both signed the U.S. Declaration of Independence. George Washington later became an honorary member. The Friendly Sons started in Seattle in 1941 and was a male-only organization until 1989, when it welcomed women members and changed its name to The Society of the Friends of St. Patrick. The change came under pressure from Seattle archbishop Thomas Murphy, who kidded that otherwise, he would start supporting the Angry Daughters of St. Brigid. In 1999, Carol Costello became the first female president of the Seattle organization.

All the photographs in this chapter are courtesy of the Friends of St. Patrick (FOSP).

APPLICATION FOR MEMBERSHIP

ANCIENT ORDER OF HIBERNIANS

NOTICE—The Constitution provides that "Any person joining this Order under an assumed name or age, or having any bodily ailment which he conceals, shall be expelled and can never be readmitted."

February 28th, 1938

TO DIVISION No. 1 , ANCIENT ORDER OF HIBERNIANS

King County, State of Washington

I hereby apply for admission into the Ancient Order of Hibernians of America, and agree that my reception and continuance in said Order shall depend upon the truthfulness of my answers to the questions which are hereto attached, which answers are made by me for the purpose of obtaining admission into the Order.

_____ Applicant

I hereby present the application of the above named William Tierney whom I have known for a period of one year past. I know him to be a practical Catholic, and one worthy in every way to become a member of this Order.

Patrick J. Smyth Proposer

A member shall not receive any benefit when disabled by any disease with which he was afflicted previous to his initiation, or from any sickness originating from intemperance, vicious, reckless or immoral conduct; or who, while in benefit, shall be found out of doors after 8 p. m. and before 7 a. m. without consent of the attending physician.

QUESTIONS TO BE ASKED BY SPECIAL COMMITTEE.

What is your name? William Tierney

What is your age? 59

Are you Irish by either birth or descent? Descent

What is your occupation? Real Estate

Where is your place of business? Seattle

Where do you reside? 5716 17th, Ave, N.,

Are you a Roman Catholic? Yes

Have you complied with your religious duties within the twelve months last past? Yes

Do you belong to any Society to which the Catholic Church is opposed? No

Were you ever a member of the Ancient Order of Hibernians; and if so, in what city or town and State? Yes, Portland, Oregon

What was the number of your Division? No 1

What was the cause of your withdrawal? moved away

Have you any physical defects or ailments of any kind; and if so, what? No

I do solemnly pledge my sacred word and honor that the answers I have given to the above questions are true.

Dated this 28th, day of February 1938

W. M. Tierney Applicant.

REPORT OF THE MEDICAL EXAMINER.

Questions to be answered by the applicant and the answers to be written by the Medical Examiner.

This is a 1938 application to join the Ancient Order of Hibernians (AOH) in Seattle. A medical exam was also required, as members were entitled to benefits in the case of illness.

Kevin G. Henehan, the 1939 Seattle division AOH president, was born in 1896 in Providence, Rhode Island, but attended elementary school in Ireland before his family moved to Seattle. In 1934, he managed future U.S. Sen. Warren Magnuson's campaign for district attorney, and from 1943 to 1947, Henehan was a state senator. He died in 1962.

On March 17, 1939, Washington's AOH celebrated its Golden Jubilee at a St. Patrick's Day banquet in the Olympic Hotel. The 300 men and women present heard a congratulatory telegram from Eamon de Valera. The keynote speaker was Maj. Gen. Walter C. Sweeney, commanding officer, Fort Lewis, who in 1917 helped establish the Military Intelligence Division of General Pershing's American Expeditionary Forces headquarters.

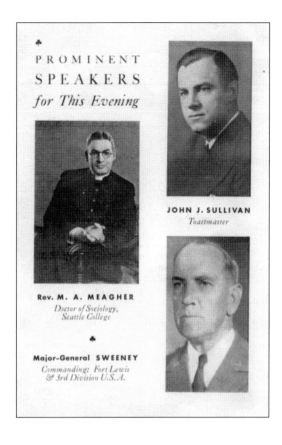

♣

PROMINENT
SPEAKERS
for This Evening

JOHN J. SULLIVAN
Toastmaster

Rev. M. A. MEAGHER
Doctor of Sociology,
Seattle College

♣

Major-General SWEENEY
Commanding: Fort Lewis
& 3rd Division U.S.A.

Jarlath J. Lyons, the AOH 1939 Golden Jubilee banquet chairman, was born in Seattle and was the son of Dan Lyons from County Mayo. A navy pilot in World War II, Jarlath was shot down three times in the Pacific theater of war. He was killed in a plane crash near Eniwitok Atoll one week before the war ended, in August 1945. His name is among the many Irish names listed on the Roll of Honor at Seattle's Garden of Remembrance at Second and University.

Banquet Committee

E. B. McGovern

Henry Broderick	Thomas S. McHugh
John D. Carmody	Judge Ed. Medley
John D. Heffernan	Judge Chas. P. Moriarty
Kevin G. Henehan	Maj. John J. Sullivan

Membership

Dr. J. L. Ashe	F. W. MacDonald
E. M. Brennan	John Mahoney
John P. Brill, Jr.	P. E. Mahoney
Henry Broderick	Jos. R. Manning
H. E. Burke	F. Arnold Manning
John A. Burns	Dr. George R. Marshall
John J. Cadigan	R. L. McGinnis
Stephen V. Carey	E. B. McGovern
John D. Carmody	Thos. S. McHugh
R. C. Clapp	Paul E. McLane
Paul D. Clyde	Frank McLaughlin
Clarence J. Colman	E. P. McLoughlin
Dr. M. Tolbert Dalton	J. A. Meade
D. P. Dennehy	Edward F. Medley
Daniel F. Donahoe	C. F. (China) Moore
T. M. Donahoe	Dr. Walter A. Moore
Judge George Donworth	Charles P. Moriarty
Roger M. Evans	J. F. Mullen
T. E. Frizelle, U. S. N.	Nate Mullen
Dr. Patrick Gallagher	Arthur A. Murphy
H. O. Gavin	Col. Arthur O'Brien
T. J. Gavin	Edward A. O'Hara
Jerry Gleeson	Edward J. O'Shea
P. J. Gilmore	Dr. Stephen T. Parker
J. P. Haley	E. C. Pennock
Wm. M. Haley	Peter K. Reilly
George N. Handley, Sr.	Floyd Reischling
David Hanley	Matthew Ryan
E. B. Hanley, Jr.	James W. Sadlier
John D. Heffernan	P. J. Smyth
Robert Heilman	Chas. E. Sullivan
Kevin G. Henehan	Maj. John J. Sullivan
James W. Hodson	Wm. A. Sullivan
Frederick Hoffman	Lloyd Sullivan
Ralph A. Horr	Jos. A. Sweeney
Henry Ivers	Frank Sydnor
Thomas J. Ivers	Chas. Tait
Wm. Jefferson	John W. Thompson
James Kelly	Kirby Torrance
James T. Lawler	Guy Trotter
Emmett G. Lenihan	Walter J. Ward
Jarlath Lyons, U. S. N.	James A. Wood
Patrick Lyons	Dr. H. Bradley Wrenn

Honorary Members

HON. FRANK C. WALKER, U. S. Postmaster General

REAR ADMIRAL CLARK H. WOODWARD, U. S. N.

MAJOR GENERAL WALTER C. SWEENEY, U. S. A.

Many familiar prominent names are listed on the banquet committee and as members at the "First Annual Dinner of the Friendly Sons of St. Patrick in Seattle" at the Rainier Club on March 17, 1941. That year, the Friendly Sons replaced the AOH as the main membership organization for Seattle's Irish.

Below is one of the tables at the 1947 St. Patrick's Day Friendly Sons banquet. Lawyer Joe Kane is at left in the photograph, but the others are unidentified. The president of the Friendly Sons that year was Kevin Henehan, former president of the Seattle AOH.

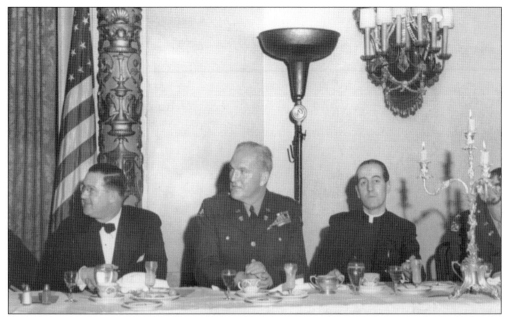

Seated at the head table at the 1948 St. Patrick's Day Friendly Sons banquet are, from left to right, incoming society president F. Arnold Manning of Manning Funeral Home; Gen. Mark W. Clark, the keynote speaker; and Fr. Albie McGrath from County Tipperary, who gave the invocation. General Clark was chief of staff of the U.S. Army Ground Forces in 1941 and deputy commander in chief of the Allied forces in the North African theater in 1942.

Pictured here in 1948, the crowd at the Friendly Sons banquet at Seattle's Olympic Hotel listens to the keynote speaker. In the center with white hair and black-rimmed glasses is Judge Edward Medley, who in 1941 became the first president of the Friendly Sons in Seattle.

Pictured here are James Dore at the piano, his brother Fred (right), and their cousin John F. Dore, practicing for the 1962 Friendly Sons banquet on March 17. The Dores were lawyers whose fathers were brothers born in Massachusetts of Irish extraction. John's father was mayor of Seattle in the 1930s. Fred was a Washington state representative from 1953 to 1959, a state senator from 1959 to 1971, and chief justice of the state supreme court from 1985 to 1993, when he retired. He died in 1996.

Pictured here from left to right, tenor Bob McGrath, Friendly Sons president Mike McKay, and Seattle city councilman Wing Luke pose at the 1963 Friendly Sons banquet. Luke was the first Chinese American on Seattle's city council. In 1965, he died in a plane crash, and Seattle's Wing Luke Asian Museum was named for him. The 1963 banquet's keynote speaker was Federal Judge George Boldt, who in 1974 issued the "Boldt Decision," giving Native American tribes the right to harvest half of the harvestable salmon and steelhead in western Washington.

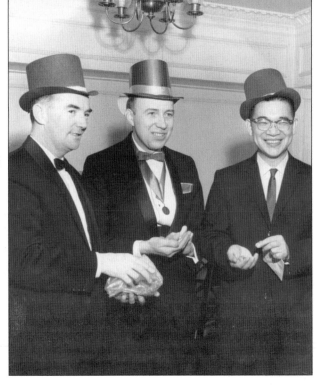

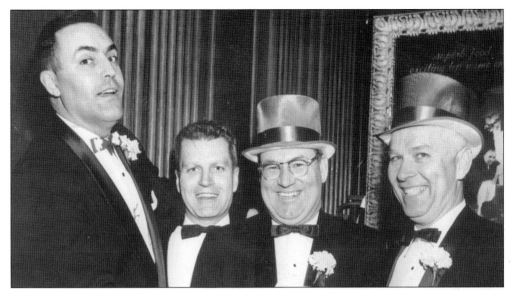

From left to right, Don Sullivan, Jim Murphy, Bill Lukoskie, and Bob Murphy (brother of Jim) pose at the 1964 Friendly Sons banquet. The Murphys' grandparents left Ireland in 1856 and settled in O'Connor, Nebraska, a town founded by the Irish Catholic Colonization Association. In 1928, the Murphys moved to Seattle, where their father worked at the *P-I*. Jim Murphy's James G. Murphy Auctioneers is now one of the largest commercial/industrial auction companies in the United States.

John Wilson, right, with Ed Fitzgerald at a 1960s Friendly Sons planning meeting, was a 1956 law graduate of Gonzaga University. He worked for the state attorney general's office and later in private practice in Everett. He was appointed to the Snohomish County Superior Court bench in 1978, serving until 1995. Known for his Irish tenor voice and his great sense of humor, Wilson died in 2002 age 75.

Pictured here from left to right in 1966, Ben Maslan shows John Miller and Jim McAteer his Bedel Bible, an Irish-language Old Testament published in 1685. Born in Dublin in 1901, Maslan came to Seattle in 1920 and was a prominent lawyer and leader of Seattle's Jewish community. He proudly carried membership cards for the Burial Society of Herzl Congregation Synagogue and for the Friendly Sons of St. Patrick and, in 1974, served as president of the Friendly Sons. Maslan's collection of 800 antique bibles went to the University of Judaism in Los Angeles upon his death in 1979. His son Bob is a rabbi in Bellevue.

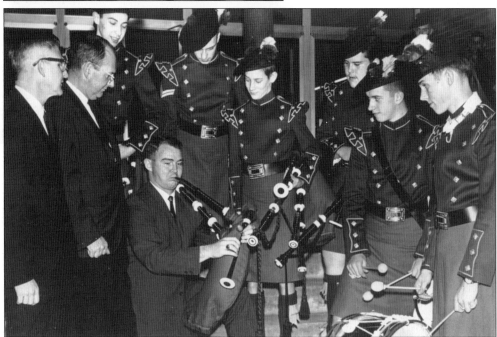

Pictured here in 1965, officers of the Friendly Sons of St. Patrick and members of the Bishop Blanchet High School Gaelic Pipe Band watch Jim McAteer try his hand with the bagpipes. Pictured from left to right are Joe McMurray (Friendly Sons treasurer), Thomas Geraghty (Friendly Sons president), Bruce Quaintance, Jim McAteer (Friendly Sons vice president), Alan Johnson, Mike McGuinness, John Philion, Dave Ebert, and Jim Burlingame. Blanchet's Gaelic pipe band wore the one-color Irish-style kilt.

Popular local Seattle radio DJ Al Cummings woke up on the morning of March 17, 1965, to find a 2,960-pound "Blarney Stone" outside his home as an early morning St. Patrick's Day "present," delivered by his good friend Mike McDowell.

Pictured here on St. Patrick's Day in 1965, Friendly Sons president Thomas Geraghty (left) watches as Seattle mayor Dorm Braman (right) is greeted by a flight attendant. In the 1960s, Seattle-based Aer Lingus employees overseeing the purchase of Boeing planes often arranged for flight attendants to come to Seattle for St. Patrick's Day and bring greetings from Dublin's mayor as well as some real shamrock.

Jim McAteer, 1966 Friendly Sons president, shows his children the large Shillelagh brought to the Seattle area from County Wicklow in 1859 by the grandfather of Friendly Sons member Edward Ederer. Since the founding of Seattle's Friendly Sons in 1941, that Shillelagh has served as the organization's symbol of office and is handed on each year to the incoming president.

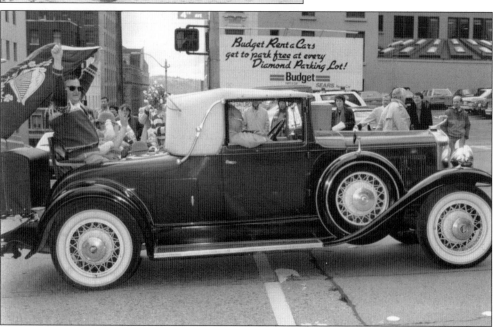

Leo Costello, president of the Friendly Sons, rode the 1983 St. Patrick's Day Parade route seated in the rumble seat of a late 1920s Packard automobile. In 1999, Leo's wife, Carol, became the first female president of Seattle's Friends of St. Patrick.

Six

MOVERS AND SHAKERS

Nearly a quarter of a million Irish immigrants came to the United States in the years prior to the Great Irish Famine (1845–1852), but the famine caused a huge increase in the number of people who left Ireland. Although there were many large families, most famine immigrants were single men and women aged 20 to 35, unskilled and Catholic, and 25 percent of them were Gaelic speaking. Between 1840 and 1860, some 1.7 million such Irish came to the United States, and a steady flow continued through the 1890s.

Many Irish immigrants became railroad workers, farmers, miners, and loggers. Although hard working, they were also family oriented, and they knew the value of an education. Succeeding generations of Irish became very successful, mainly because their parents and grandparents made sure their children attended school. All across the United States, area schools were started in Irish farmhouses, and the Irish were at the forefront in building schools and churches and in establishing towns. Irish pioneers helped settle communities, and it's no wonder their children became leaders in industry, commerce, and politics.

That was also true in the Seattle area. Judge Thomas Burke, known as "The Man who built Seattle," John Collins, Thornton McElroy, John Harte McGraw, and John Miller Murphy were first- or second-generation Irish who helped shape Seattle in its first 50 years. This chapter highlights some of the other Irish who were prominent in the next 100 years.

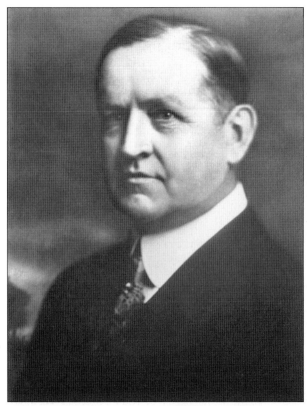

Born in New York to Irish immigrants Michael and Anna Pigott, William Pigott (1860–1929) sold steel supplies to loggers in Seattle starting in 1895. Business boomed during the Klondike gold rush, and in 1901, he started producing logging wagons and railcars. In 1905, he started the Seattle Car Manufacturing Company, which later became Pacific Car and Foundry Company, a name it retained until 1972 when it changed to PACCAR, Inc. In 1962, the company's structural-steel division fabricated the steel for constructing the Space Needle, and today PACCAR is mainly known as a worldwide manufacturer of premium light, medium- ,and heavy-duty trucks. Seattle University's Pigott Auditorium is named for the family. (Courtesy PACCAR.)

Jim Casey (1888–1983), pictured at right in 1922 and below in 1952, was born in Nevada to John Casey from County Cork and Annie Sheehan, whose parents were from County Cork. In 1897, the Caseys moved to Seattle, and John prospected in the Klondike. In 1902, John died, leaving Annie to raise four children alone. Jim, the eldest, started delivering messages for a local Seattle telegraph office at age 11. In 1907, at age 19 and starting with two bicycles, one phone, and an office in the basement of a downtown Seattle saloon (now Waterfall Park), Jim and his brother George and two friends founded the American Messenger Service, which in 1919 was renamed United Parcel Service. UPS now operates in more than 200 countries worldwide. Annie Casey died in Seattle in 1962. (Both courtesy UPS.)

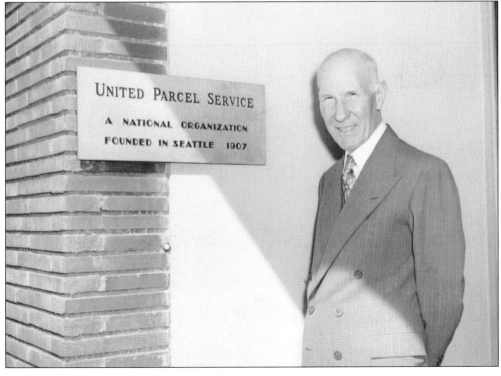

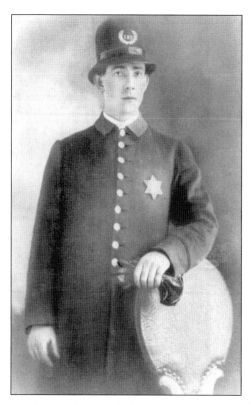

James O'Brien was born in County Cork and came to the United States in 1903. He joined the Seattle Police Department and rose through the ranks to become a detective. On January 21, 1921, he and his partner encountered a murder suspect downtown near Second and Columbia. Shots were exchanged, and O'Brien was killed, leaving a wife and four children, one of whom was John L. O'Brien. (Courtesy Karen O'Brien.)

In 1938, John L. O'Brien lost the Democratic primary for the Washington State Senate, beaten by friend and neighbor Albert Rosellini, who later became governor. Starting in 1939, O'Brien served 26 terms in the Washington State House of Representatives. He was speaker of the house from 1955 to 1963 (the *Olympian* newspaper dubbed him "The fastest gavel north of Pecos!"), speaker pro tempore for 18 years, and later speaker emeritus. The book pictured at right was published in 1990 by the UW Press. (Courtesy Daniel Jack Chasan.)

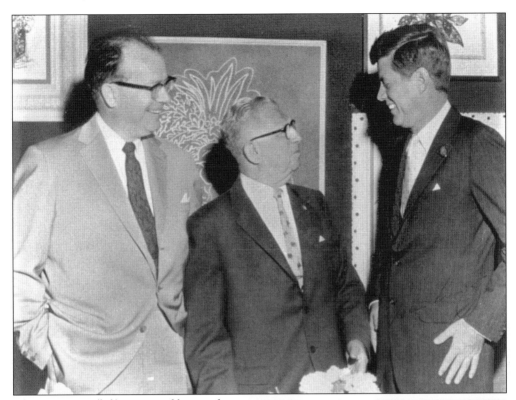

John L. O'Brien (left) is pictured here with Joseph Gluck and Sen. John F. Kennedy at the 1958 Jefferson-Jackson Day dinner in Seattle. O'Brien was Kennedy's host and driver during his visit. In 1989, the house office building in Olympia was renamed the John L. O'Brien Building for the man who was the longest-serving state-house member in U.S. history when he was defeated for reelection in 1992. (Courtesy Karen O'Brien.)

Born in New York to Irish immigrant parents, Patrick Fitzsimons became Seattle police chief in 1978 and was recognized as one of the nation's top cops while running a highly competent and ethical department. He retired in 1993 after serving 15 years, the longest tenure of any Seattle police chief, but still serves on an FBI policy-advisory board. His brother Richard lost his life on September 11, 2001, while serving as fire safety director in New York's World Trade Center. (Courtesy Chief Fitzsimons.)

Frank McLaughlin was president of Seattle's Puget Sound Power and Light Company from 1931 to 1960, successfully steering the company through the Depression while dealing with widespread calls for public ownership of utilities. He reportedly gave over 3,000 speeches as CEO. A member of the AOH and the Friendly Sons, McLaughlin retired in 1960 and died in 1972. (Courtesy UW Digital Collections, UW-26605z.)

Henry Broderick (1880–1975) was born in Minneapolis to Irish immigrant parents. After moving to Seattle in 1901, he became president of the city's largest real estate firm. In 1915, he sold the Perry Hotel to Mother Cabrini (now St. Cabrini) to start Columbus Hospital (later Cabrini Hospital), accepting rosary beads instead of a $7,500 commission. He was a trustee of the 1909 and 1962 Seattle World's Fairs, an SU regent, a member of numerous boards, and a member of the Friendly Sons of St. Patrick. (Courtesy UW Portraits Collection.)

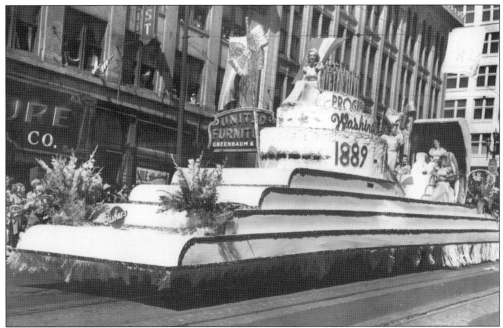

In 1939, Kathleen Forhan, pictured above at the rear of the float, reigned as Potlatch Festival Queen in Seattle's Potlatch Parade, which also celebrated Washington's 50th anniversary of statehood. Although World War II temporarily halted the Potlatch Festival, it was revived in 1950 as Seafair, now an annual summer event. In 1946, Forhan, whose parents were from County Kerry, married Eugene Corr, whose parents were from County Tyrone. (Courtesy Casey Corr.)

Son of parents from County Tyrone, Eugene Corr (1923–2005), pictured here in 1960, joined the Seattle police force in 1947 and became assistant police chief. He risked his life exposing Seattle police corruption and led efforts to increase the number of blacks and women on the force, encountering fierce opposition within the department. Dubbed "Clean Gene," he resigned in 1969. In 1983, President Reagan named him U.S. federal marshal for Western Washington. (Courtesy Casey Corr.)

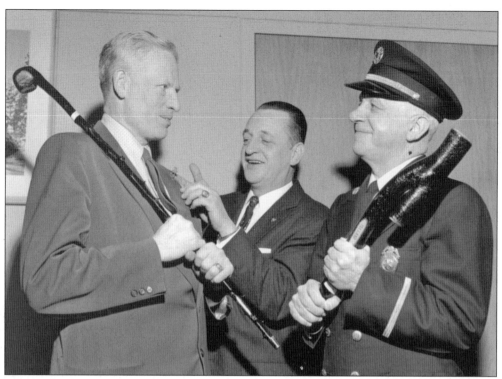

Pictured here on St. Patrick's Day in 1955, police chief H. J. Lawrence and fire chief William Fitzgerald brandish their shillelaghs while an unidentified man pins shamrock on their lapels. Fitzgerald served the longest tenure of any of Seattle's fire chiefs, from 1938 to 1963. Lawrence was police chief from 1952 to 1961. (Courtesy MOHAI, *Seattle Post-Intelligencer* Collection, 86.5.6940.1.)

Mary Eileen Kavanagh and Joe Kane pose on their 1946 wedding day in Seattle. Kane, the son of a Galwayman, boasted that as a kid he shook the hands of Irish revolutionary leaders Michael Collins and Eamon de Valera. Born in New York, he settled in Seattle in 1946, worked for the ACLU, and later was a law partner of future governor John Spellman. Kane represented labor unions and minorities, taught law at SU, and was a Democratic Party activist. He died in 2001 at age 93. (Courtesy John J. Kane.)

Two of Patrick Brady's great-grandparents were from County Monaghan and two from County Armagh, and he was born in South Dakota in 1936. After his family moved to Seattle, he attended Briscoe Memorial School and O'Dea High School, both run by the Irish Christian Brothers, and graduated from SU. He served two tours of duty in Vietnam as a Medivac-helicopter pilot and flew more than 2,000 combat missions, evacuating over 5,000 wounded soldiers. During 34 years in the service, he earned both the Congressional Medal of Honor and the Distinguished Service Cross, one of only a handful so honored. These photographs, taken in 1964 in Vietnam, show Brady evacuating a wounded soldier and receiving one of his numerous battlefield decorations. Brady lives in Lake Tapps, south of Seattle, and serves as chairman of the Citizens Flag Alliance. (Courtesy Major General Brady.)

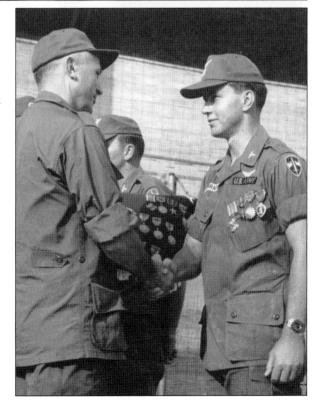

Dave Beck (1894–1993) was born in California, his mother the daughter of Irish immigrants. He drove a laundry truck in Seattle in 1910 and became a full-time Teamsters' organizer in 1926. Beck was elected as the International Brotherhood of Teamsters' president in 1952 and built the union into one of the world's largest. In 1957, he was found guilty of income-tax evasion and other irregularities and served two years at McNeil Island Federal Penitentiary but, in 1975, was pardoned by President Ford. (Courtesy Teamsters Local 117.)

A veteran of World War II and the Korean War, Don McGaffin (1926–2005) was a legendary Seattle newsman and award-winning journalist on KING-TV in the 1970s and early 1980s. He fearlessly exposed corruption and scandal and exposed dangerous business practices. In 1979, British soldiers detained him for hours in Northern Ireland when he was near where a bomb exploded. Another time he was kidnapped by guerrillas in El Salvador. (Courtesy Mimi Sheridan.)

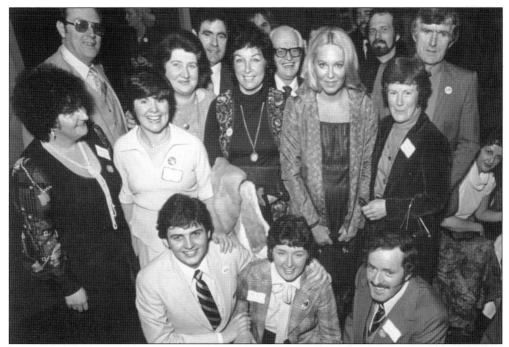

In 1980, Joan Kennedy (center with blond hair) was the major attraction at an "Irish-Americans for Ted Kennedy for President" event in Seattle. She is surrounded by, clockwise from left, Mary Shriane, Joe O'Neill, Maura Barnes, Monica McGlynn, Colm McGlynn, Eithne McAleese, unidentified, Bill Barnes, Joe McAleese, Bernadette Noonan, Frank Shriane, Kay McKenna, and Jim Dinan. (Courtesy Mary Shriane.)

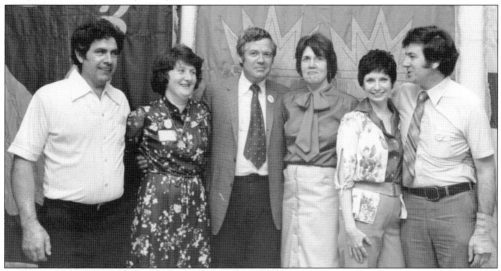

In 1980, state senator Jim McDermott won the Democratic primary for governor but lost in the general election to Republican John Spellman, another Irishman. Both candidates tapped into Seattle's Irish community for support with "Irish-Americans for . . ." committees. In 1988, McDermott was elected as U.S. congressman representing Seattle and is currently serving his 10th term in Congress. Pictured above are, from left to right, Colm and Monica McGlynn, Jim and Virginia McDermott, Maureen and John Keane.

Martin J. Durkan Sr. (1923–2005) was born in Montana, the son of Martin Durkan from County Mayo. From 1956 to 1976, Durkan served two years in the state house and 18 years in the state senate, becoming chairman of the powerful Ways and Means Committee. After unsuccessful races for governor and for the U.S. Congress, he became one of the most influential lobbyists in Olympia. Often compared to the Kennedys, all eight Durkan children are involved in public life. (Courtesy Jenny Durkan.)

Pictured here in 1947, Murdock and Mary Ellen MacPherson prepare to board a plane for their honeymoon. Murdock's grandmother was born in County Mayo and his mother, Anna Ahern, married William MacPherson in 1917. In 1933, William started a real estate company, and after returning from World War II, Murdock and his brother took over running MacPherson Realty. In 1988, Murdock sold his interest, formed a new development company, and got more involved in horse racing. Since 1995, he has annually organized Irish Day at the Races at Emerald Downs in Auburn. (Courtesy Murdock MacPherson.)

Mick McHugh, pictured above in 1972 with Mary Schaede, is a well-known restaurateur and guiding force in Seattle's Irish community. He and his partner Tim Firnstahl opened Jake O'Shaughnessy's in 1975, which, until it closed in 1992, was Seattle's best-known Irish establishment. Another of their restaurants, FX McRory's, was written up in *Time* magazine after the 1980 unveiling of Leroy Neiman's painting of St. Patrick's Day at McRory's. McHugh was the main impetus behind the 1986 establishment of the Seattle Galway Sister City relationship. (Courtesy Michael O'Sullivan.)

Joe Heaney (1919–1984) speaks in 1982 after receiving a National Heritage Award from the National Endowment for the Arts. Born in County Galway, Heaney was Ireland's most famous *sean-nós* (old-style) singer, composer, and storyteller. He moved to the United States in 1966, and in 1980, he became artist in residence and teacher of *sean-nós* singing at UW. His Seattle legacy includes UW's Joe Heaney Collection, the most heavily used collection in the UW Ethnomusicology Archives. (Courtesy Cáit Callen.)

John Spellman's ancestors emigrated from County Roscommon, and he was born in Seattle in 1926. He graduated from Seattle University and Georgetown Law School, served in the U.S. Navy, and practiced law. In 1969, he was elected King County executive, defeating former governor Albert Rosellini, and was twice reelected. In 1976, he oversaw the building of the Kingdome, the first home of the Seattle Mariners and Seattle Seahawks. In 1980, he was elected governor of Washington and served one term. After leaving office in 1985, Spellman returned to private law practice. In 1988, he led a delegation to Galway, where he officially signed the Seattle Galway Sister City agreement on behalf of the City of Seattle. Pictured above is Spellman in his office in Olympia, and shown below at right in 1984 is Spellman visiting with another Irishman, Pres. Ronald Regan, at the White House. (Both courtesy Governor Spellman.)

At the 1981 Irish Week Proclamation Luncheon at Jake O'Shaughnessey's, Gov. John Spellman, singing bartender Robert Julien, and the governor's wife, Lois, lead the crowd in singing "When Irish Eyes are Smiling." Well known for his Irish tenor voice, Spellman still regularly attends Irish functions and is often called upon to lead the crowd in singing Irish songs. This photograph appeared in the *Seattle Post-Intelligencer* on March 13, 1981.

Born Rita McGarry (1922–2006) in Belfast, she married American Frank Matheny in Dublin near the end of World War II. The Mathenys moved to Marysville in 1966, where Rita ran for office and was elected mayor. She was a Democratic National Committee woman and a delegate to the Democratic National Convention in 1976. In 1991, she presided over Marysville's centennial celebrations, marking the incorporation of the town in 1891 by Irishman James Comeford. (Courtesy City of Marysville.)

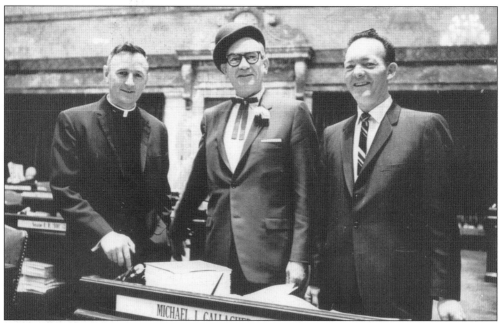

Fr. Brendan Gallagher from County Mayo poses with state senators Mike Gallagher (center) and Lowell Peterson (right) on St. Patrick's Day in 1965 on the senate floor in Olympia. Mike Gallagher spent 24 years serving in the state house and senate from 1943 to 1967, representing Seattle's 45th District. He was a delegate to the 1948 Democratic National Convention that nominated Harry Truman for president. Peterson was from Marblemount and represented that district in the state senate from 1965 to 1987. (Courtesy Brendan Gallagher.)

Born in England of Irish parents, Dr. Giovanni Costigan (1905–1990) joined the UW faculty in 1934. He became one of America's most distinguished historians and had a passion for Ireland and Irish history. His *History of Modern Ireland* was essential reading, and in 1967, he did 12 programs on Irish history for KCTS-TV. He was one of the UW's most popular professors for generations of students. (Courtesy UW Portraits Collection.)

Twins Johnny and Eddie O'Brien were born in 1931, grandsons of a man from County Clare, and they became All-American basketball stars with the SU Chieftains in the 1950s. Called the "Golden Twins," the O'Briens led the Chieftains to the NCAA tournament for the first time in 1953. Johnny, the team's five-foot-nine center, was the first NCAA player to score over 1,000 points in a season, scoring a career total of 2,733 points. His brother Eddie later became SU athletics director. (Courtesy Seattle University.)

John Doyle Bishop was a flamboyant downtown couturier with his own women's clothing label. Annually on March 17, he painted a green stripe on Fifth Avenue outside his store and often arranged to get arrested for the publicity. He was grand marshal of Seattle's first official St. Patrick's Day Parade in 1972, and when he died in 1980, one of the organs in St. James Cathedral was purchased with a Doyle Bishop bequest. (Courtesy MOHAI, *Seattle Post-Intelligencer* Collection, 86.5.19084fp.28.)

Born in 1897, Walter Clarke, who is pictured here in 1960, at one time owned 22 restaurants in Seattle, Portland, Tacoma, and Yakima. His favorite was the Dublin House, Seattle's first modern Irish-themed restaurant. Before it opened in the late 1950s, Clarke took an architect to Ireland, attended an Irish cooking school, and purchased numerous antiques. Clarke sold his restaurant chain in 1970, and the Dublin House was closed a few years later. (Courtesy MOHAI, 2002.46.14.)

From 1950 to 1984, Ed Donohoe (1918–1992) probed the foibles of politicians and others in his "Tilting the Windmill" column in the *Washington Teamster* newspaper. He roasted them with descriptive nicknames, such as Senator "Slippery Slade" Gorton, the League of Women "Vultures," and "Smokey the Bore" (the fire chief). He annually emceed the St. Patrick's Day luncheon at Seattle's Catholic Seaman's Club, where he again would roast everyone except the Teamsters. (Courtesy Teamsters Local 117.)

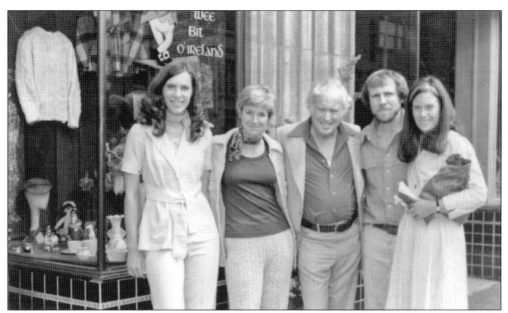

From left to right, Cathy Ann Davies, Tracy O'Day, Leon Uris, Michael O'Sullivan, and Jill Uris pose outside the Wee Bit O'Ireland store in 1975 following an *Ireland, A Terrible Beauty* book signing. O'Sullivan opened his Pioneer Square store in 1970, and it carried a wide assortment of Irish woolens, books, records, and other items, picked up on O'Sullivan's regular visits to Ireland. O'Sullivan was also involved in Seattle's St. Patrick's Day Parade and the Friendly Sons. In 1986, he converted his store to an antique shop and later retired to Belfair. (Courtesy Michael O'Sullivan.)

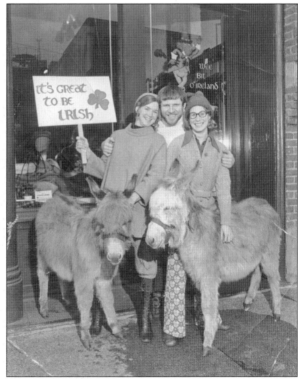

Karen Howe, Michael O'Sullivan, and Tracy O'Day pose outside the Wee Bit O'Ireland store with miniature Irish donkeys in 1974. Brought from Ireland as a promotion, the small donkey was named Bridget and the larger one Liam. However, the names had to be switched when it was later discovered that the large one was female and the small one was male! But they made a splash in Seattle and were later donated to a petting zoo. (Courtesy Michael O'Sullivan.)

In 1974, county executive (and later governor) John Spellman and Michael O'Sullivan help organize the start of Seattle's St. Patrick's Day Parade. O'Sullivan lost a leg in Vietnam and since then has worn a wooden one. For special occasions, such as for St. Patrick's Day, he wears his "dress leg" (pictured at left), which he had specially engraved with Irish and Celtic designs. (Courtesy Michael O'Sullivan.)

At the 1975 Irish Week Proclamation Luncheon are, from left to right, proprietor Mick McHugh of the newly opened Jake O'Shaughnessy's, television journalist Charley Royer, and Fr. John Madigan. Royer later became Seattle's longest serving mayor, from 1978 to 1990, and in 1986, signed the official agreement formalizing the sister city relationship between Seattle and Galway. Madigan, from County Limerick, is the last Irish-born priest to come to Seattle directly after ordination. (Courtesy Father Madigan.)

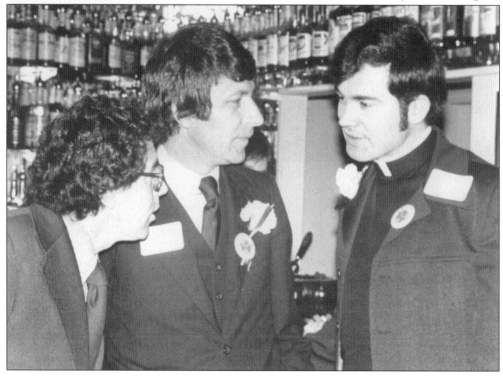

Maureen Keane talks to Irish ambassador Padraic McKernan at a 1987 dinner in Bellevue. McKernan was guest of honor at a fund-raiser for the Ireland Fund, an organization that supports peace-related programs in Ireland. He is now Irish ambassador to France. Keane, whose mother is from County Louth, taught Irish dancing in Seattle for many years and is a noted nutritionist and author of 14 books.

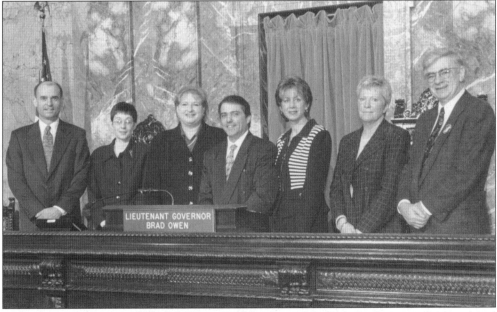

Irish government minister Síle de Valera, granddaughter of the Irish revolutionary leader, visited Seattle for St. Patrick's Day in 1998 and also visited Olympia. Pictured with her on the floor of the senate are, from left to right, Brent Heinemann, Irish vice-consul Sinéad NicCoitir, Minister de Valera, Lt. Gov. Brad Owen, Juliette Schindler-Kelly, Sheila Clifford, and John Keane.

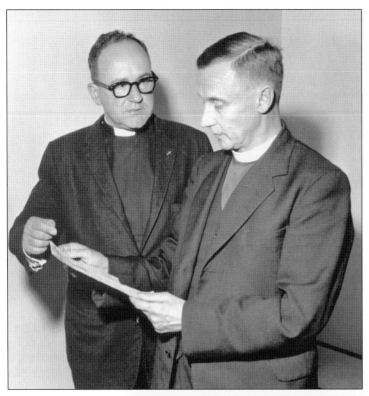

Visiting from Ireland in 1960 was the Very Rev. George Simms, pictured at right with the Venerable Walker McNeil from the Episcopal Archdiocese of Olympia. Simms was the Church of Ireland (Anglican) archbishop of Dublin from 1956 to 1969 and archbishop of Armagh and primate of all Ireland from 1969 to 1980. Internationally recognized as an expert on the Book of Kells, he died in 1991. (Courtesy MOHAI, *Seattle Post-Intelligencer* Collection, 86.5.35.462.)

In 1957, Dick Foley (left), the grandson of an Irish immigrant, joined with three UW fraternity brothers to become The Brothers Four, when they were lured as a prank to a fake audition but were hired anyway. Their 1960s hit singles, "Greenfields," and "The Green Leaves of Summer," brought them worldwide concert tours and million-selling records. Dick Foley left the group in 1988, became a television broadcaster, and now works with Seattle area social-service agencies. (Courtesy Dick Foley.)

In the 1950s, Seattle was the nation's hydroplane-racing capital, and the seven-liter modified class dominated from World War II up to the early 1970s. Pictured above in 1957 on Seattle's Lake Washington, pilot Roger Murphy in the *Galloping Gael* set a record of 140.351 miles per hour for the mile in the seven-liter class. (Courtesy MOHAI, *Seattle Post-Intelligencer* Collection, 86.5.13443.)

In the late 1950s, John Dore Jr., arranged for some of his 14 children to take a ride on a cart pulled by a donkey, something they had seen in the movie *The Quiet Man* and in travel brochures promoting Ireland. Dore's father was mayor of Seattle in the 1930s.

Born in Tacoma in 1934, Paul Berg adopted the professional name Pat O'Day in 1959, taking the name from Seattle's O'Dea High School. At KJR radio, O'Day became Seattle's highest-profile DJ of the 1960s and early 1970s and operated an extensive teen-dance circuit. He promoted the Beatles and handled all U.S. bookings for Jimi Hendrix, the Seattle guitarist. In the Pacific Northwest, O'Day, pictured at left in 1960, was Mr. Rock 'n' Roll. (Courtesy MOHAI, *Seattle Post-Intelligencer* Collection, 1986.5.37681.1.)

Born in Montana, Thomas "Red" Kelly (1928–2004), an Olympia-area musician and bar owner, as a joke in 1976, founded the OWL Party, which stands for "Out With Logic, On With Lunacy," and ran for governor, declaring that "unemployment isn't working" and promising to "fight the heartbreak of psoriasis." Kelly got eight percent of the vote that November. (Courtesy Tacoma Public Library.)

Seven

THE IRISH COMMUNITY
AT WORK AND PLAY

Starting in 1940 and throughout the 1950s, nearly three quarters of a million people left Ireland, mostly for Britain but many of them for the United States. A large number of the Irish born in the Seattle area today came from Ireland during those years.

Leaving home and family behind to come to an America they didn't know was a sad and emotional time for most. They usually had little idea what to expect when they arrived, and they had no idea when they would be able to return home. Until air travel became economically feasible in the 1960s, travel between Ireland and Seattle usually involved three to five days by boat from Cobh in County Cork to New York, and several more days on a train from New York to Seattle. In addition, travelers often had difficulty with the food and customs.

The loneliness of being away from home was partly compensated by the sight of friends or relatives they hadn't seen in years. Most Irish people would gravitate to the Irish clubs that existed, as these places were where leads on jobs and introductions were obtained. Jobs were usually readily available, as the Irish were largely perceived as being hard workers. Parties and dances, called *céilis*, were common, and Irish priests and churches were links to home. Irish music, Gaelic football, Irish stepdancing, sing-alongs, and *céilis* were ways Seattle's Irish community members nurtured their Irish identity.

Seattle's Gaelic Club members pose at Seattle University following their 1954 communion breakfast. The two priests in the middle are Fr. James McGoldrick, S. J., from County Sligo and

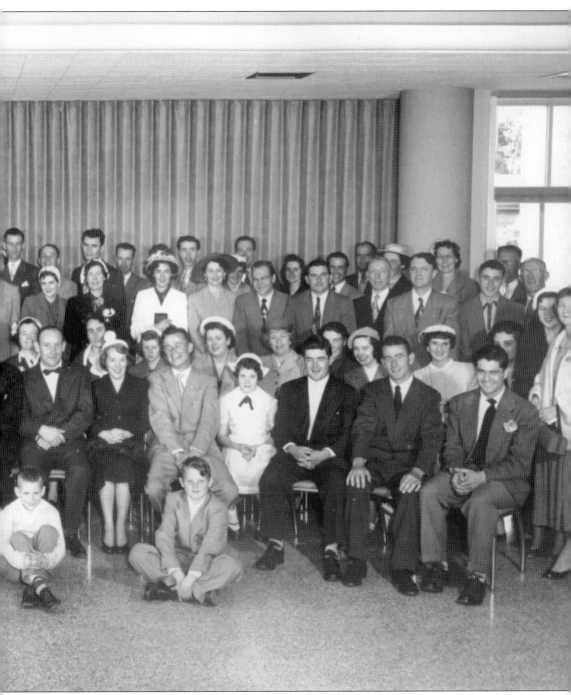

Fr. William Treacy from County Laois. The Gaelic Club was composed mainly of the recently arrived Irish and their spouses and friends. (Courtesy Finian Rowland.)

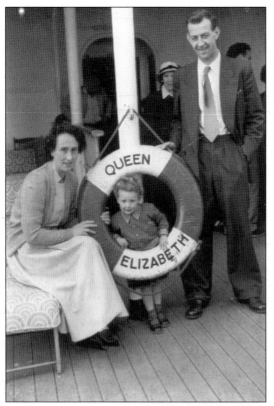

In 1953, Maureen and Phil Fitzpatrick and their daughter Maria spent five days sailing from Southampton, England, to New York on the *Queen Elizabeth*. The Fitzpatricks were from Dublin, and they traveled on to Seattle to join Maureen's brother, Danny Bray. Three more of Maureen's siblings later followed from Ireland. (Courtesy Maureen and Phil Fitzpatrick.)

Pictured in 1956 doing the "Siege of Ennis" at an Irish Club *céili* are as follows: (first row) John Boyle and Colleen Cullen; (second row) Margie Jones, Leo Bray, and Maureen and Phil Fitzpatrick. (Courtesy Eileen Pat Dunn.)

Pictured in 1956, Finian Rowland from County Mayo poses with John Boyle, who was born in County Donegal. Rowland came to Seattle in 1950 to enter St. Edward Seminary but left after two years. He spent 34 years working for Seattle's Bell Telephone Company where his nickname was "Irish" for everyone from the company president on down. (Images on pages 101 and 102 courtesy Eileen Pat Dunn.)

A group poses at an Irish Club function in 1956. They are from left to right as follows: (first row) Maureen Nolan, Mike Nolan, Colleen Nolan, and Nellie Nolan; (second row) Eileen Pat Nolan, Fr. Jimmy Neville, Fr. Brendan Gallagher, Fr. John McGlynn, Fr. Pat Lyons, and Mickey Nolan. Nellie Cullen Nolan came from Ireland in 1923 to join Bridget Aylward, the "Queen of Alaska."

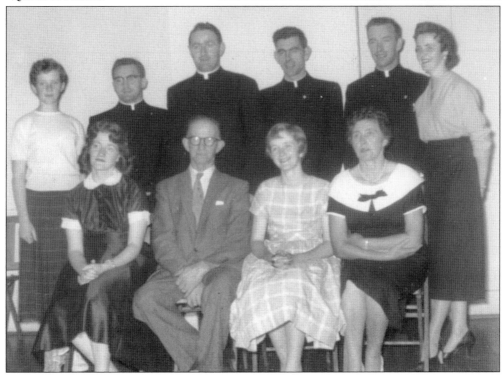

Ellen McCue was born in Seattle to parents from County Donegal. Emmett Casey was born in New York to parents from Belfast. Casey met McCue at an Irish Club party in Seattle, and they were married in 1955. Three years later, shortly after the photograph at left was taken of them at an Irish Club picnic in Seattle, they moved to Belfast, where they raised a family of eight children. Emmett died in 1997 and Ellen in 2006.

Pictured from left to right in 1956 at an Irish Club planning meeting are John Boyle, Mike Murdock, Nellie Nolan, Catherine Cunningham Murdock, Fr. John McGlynn, Agnes Redding, Nana Cunningham, and Margie Jones.

Members of Seattle's Irish-born community entertain the crowd at the Seattle navy base on Pier 91, March 14, 1958. They are, from left to right, Jerry O'Leary and his sister Ann O'Leary from County Cork, Dennis Doohan from County Donegal, Bernadette McKevitt from County Louth, Pat Dolan from County Cavan, Christina Duggan from County Waterford, and Una Bray from Dublin. Within a few years, Ann O'Leary married Dennis Doohan, and Pat Dolan married Christina Duggan. (Courtesy Tom Quinlan.)

Pictured here demonstrating a four-hand reel at the Seattle navy base in 1958, Úna Bray and Pat Dolan (far left) face Jerry O'Leary and Christina Duggan. Irish music, singing, and dancing were things emigrants brought with them from Ireland, and most make every effort to keep traditions alive. (Courtesy Tom Quinlan.)

Pictured here demonstrating a two-hand reel to the crowd at the Seattle navy base in 1958 are Ann O'Leary (later Ann Doohan) and Christina Duggan (later Christina Dolan). Looking on is Ann's brother, Jerry O'Leary, and some navy members. (Courtesy Tom Quinlan.)

Tom Quinlan from County Tipperary sings for the crowd at the Seattle navy base. Quinlan came from Ireland to the Seattle area in 1957 to join an uncle who worked for Boeing. Early on he worked for Bethleham Steel and later in construction and for the City of Gig Harbor. Graced with a lovely tenor voice, he was regularly called upon to sing at Irish parties and functions. (Courtesy Tom Quinlan.)

From left to right, Pat Dolan from County Cavan, Charlie McGlynn from County Donegal, Tom Murphy from County Tipperary, John Duggan from County Waterford, Colman Foley from County Galway, and Tom Quinlan from County Tipperary gather outside a 1960 Irish wedding reception in Seattle. (Courtesy Tom Quinlan.)

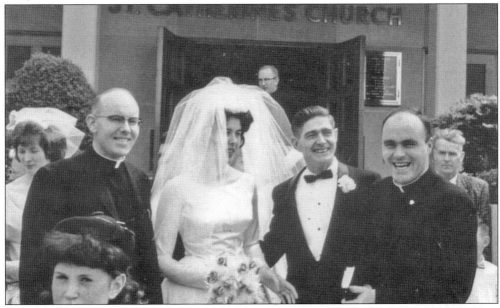

From left to right, Fr. Jarlath Heneghan from County Mayo, Mary Heffernan from County Wicklow, Mike O'Malley from County Mayo, and Fr. Gerry Lovett from County Kerry are pictured here after the Heffernan-O'Malley wedding in Seattle in 1963. As co-owner of Tuffey and O'Malley Contractors, O'Malley regularly provided jobs to young Irishmen arriving in Seattle. He died suddenly in 1996, and the *Seattle Times* ran his obituary with this headline: "Contractor Mike O'Malley, 66; Irish community's heart and soul." (Courtesy Mary Shriane.)

Ann Kavanaugh LaPoma, left, pictured above with her niece, Eileen Sullivan, was born in Clontarf, Minnesota, a town founded in 1876 by Irish immigrants and named after the Dublin suburb. Her parents, Eileen's grandparents, were born in County Waterford. From the 1970s, Ann and Eileen were officers in Seattle's Irish organizations, and Ann served as Irish Heritage Club membership secretary from 1982 until her death, in 1999.

The folk-music revival of the 1960s and Seattle's Folklife Festival in the 1970s helped make traditional Irish music very popular in Seattle. No Comhaile was one of several excellent traditional Irish groups that regularly played at Jake O'Shaughnessy's, Mrs. Malia's, and Murphy's Pub. Pictured here from left to right in 1978 are No Comhaile members: (first row) Colin Manahan and Nick Voreas; (second row) Dale Russ, Mike Saunders, and Mark Graham. Graham later played with well-known Irish fiddler Kevin Burke as Open House. (Courtesy Dale Russ.)

Phil White (Uilleann piper) and Finn MacGinty (guitar and vocals) watch Randall Bays (fiddle), Conor Byrne (normally fiddle), and Paul Keating (bodhran and vocals) at a *seisúin* at the old Murphy's Pub in 1984. A master Irish fiddler, Randal Bays has performed all over the United States, Europe, and Canada and is cofounder of the annual Friday Harbor Irish Music Camp. (Courtesy Randall Bays.)

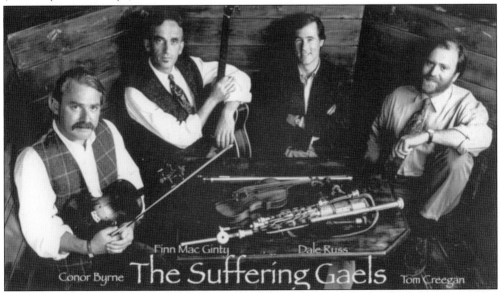

In the 1980s and 1990s, The Sufferings Gaels was the premier traditional Irish music group in the Seattle area. Some of the players have changed over the years, but above are, from left to right, Conor Byrne from Dublin on fiddle, Finn MacGinty from Westmeath on guitar and vocals, Dale Russ from Seattle on fiddle, and Tom Creegan from Dublin on Uilleann pipes. The group grew out of the regular Sunday sessions at the old Murphy's Pub. (Courtesy Finn MacGinty.)

In 1973, dancers from the Commins School of Irish Dance performed at the Museum of History and Industry in the "Christmas Around the World" show. Pictured from left to right are Sara Pringle, Adrian Commins, Colleen McDonald, Tom Commins, and Brigid McDevitt. The Commins School, run by Jetta Commins from County Down, was Seattle's only children's Irish dancing school in the 1970s, but today there are over 10 Irish dancing schools in the Seattle area. (Courtesy Maggie Corrigan.)

Pictured here in 1973, these dancers from the Commins School of Irish Dance are, from left to right, as follows: (first row) Eamon Commins, Tara O'Doherty, Jimmy Commins, and Sara Pringle; (second row) Tom Commins, Colleen McDonald, Adrian Commins, Brigid McDevitt, and Joseph Commins; (third row) Erin Duffy, Stephenie Scillo, Margo O'Doherty, Lauren Cox, Margaret Pringle, and Maureen Duffy. Maggie Pringle Corrigan now teaches one of Seattle's largest Irish dancing schools, the Baile Glas Dancers. (Courtesy Maggie Corrigan.)

Pictured from left to right are Irish dancers Julie Raney and her sister Erin with Colleen Flanigan and her sister Maureen in 1981. These dancers were with the Maureen Keane School of Irish Dance, which has since evolved into the Tara Academy of Irish Dance, run by the Raney sisters.

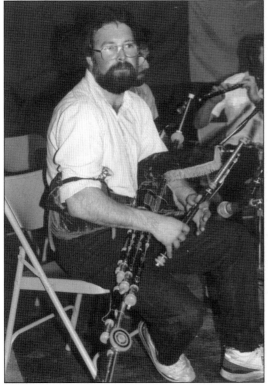

Seattle's Irish Pipers' Club was formed in 1981 and promotes the playing of the Uilleann pipes, Ireland's unique form of bagpipe, as well as all kinds of traditional Irish music. The local club helps organize Irish music sessions several times weekly in Seattle-area Irish pubs. Pictured at left is Ciaran O'Mahony from County Cork playing the Uilleann pipes at a session in the 1980s.

Pictured here is Seattle's 1959 Gaelic football team. They are, from left to right, as follows: (first row) Mark McAndrew, Mike Owens, Vincent Kelly, Gerry Lovett, Ernie Truelson, Jim Coyne, and Neil Lane; (second row) Martin O'Malley, Bobby Truelson, Brendan Gallagher, Tom Quinlan, John O'Sullivan, Billy Hagen, Dónal McKevitt, Tim Daly, and Kevin Sullivan. The young boy is Matt Daly. (Courtesy Tom Quinlan.)

Pictured here is Seattle's 1964 Gaelic football team, which played San Francisco at West Seattle Stadium. They are, from left to right, as follows: (first row) Con Sullivan, Walter Poletick, Fr. Tom Daly, Frank Shine, Tom Sampson, Nate Walsh, and Frank Shriane; (second row) unidentified, unidentified, Fr. Jerry Lovett, Fr. Jarlath Heneghan, Ernie Truelson, Fr. John McMullen, unidentified, and unidentified. (Courtesy Tom Quinlan.)

Since 1979, a Seattle Gaelic football team has competed against teams from Tacoma, Portland, Vancouver, Calgary, and Edmonton. Among those pictured from the 1979 team are as follows: (first row) Marty O'Malley, Frank Shriane, Tony Coyne, Joe Coyne, Danny Quinn, Tommy Quinlan, Tom Tynan, and John Keane; (second row) Brian Fitzgerald, Charlie McAleese, David Barnes, Bill Barnes, Ger McAleese, John Duggan, Mark Gassoin, John O'Malley, and Mike O'Malley (coach).

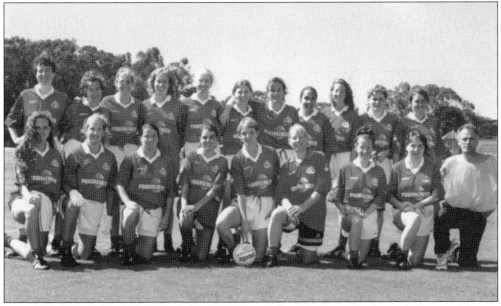

The first ever Seattle Gaels Women's Gaelic football team is pictured here at the 1997 North American Finals in San Francisco. They are, from left to right, as follows: (first row) Eva Swayne, Stephenie McGuigan, Alison McGuigan, Kim Carson, Bernie McLoughlin, Kelly Wilson, Maria Lyons, Ann Gill, and Thomas Jordan (coach); (second row) Elizabeth MacKenzie, Barbara Dey, CeCe McLoughlin, Sheila Griffin, Linda Dalton, Mary Froelich, Maeve Lyons, Delia Valeriano, Stacie Netherby, Sunniva Smith, and Shannon Roche.

Pictured here in 1960, Frank Shriane (right) from County Roscommon relaxes in Korea with some of his U.S. Army buddies. Shriane came to Seattle in 1958 and married Mary Keating from County Carlow in 1968. They raised three children in their Capitol Hill home, which was a center for Seattle's Irish community activities. In 1982, Mary helped start the annual Irish Festival at the Seattle Center. (Courtesy Mary Shriane.)

At the 1973 Irish Picnic organized by the Irish-American Club are, from left to right, Frank and Mary Shriane and four-year-old Brendan and Kitty and Gordon Jacobsen with two-year-old David. Kitty was from County Westmeath and came to Seattle in 1968. She and Gordon were married in Seattle in 1970, and their son David is now president of Seattle's Irish Heritage Club. (Courtesy Mary Shriane.)

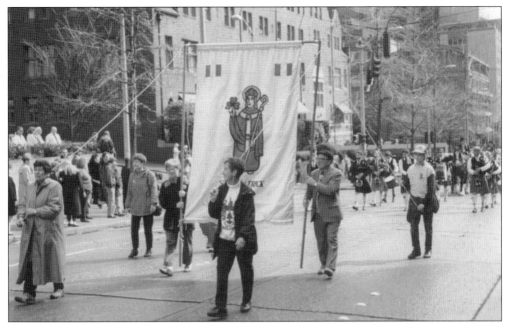

Among those carrying the banner of St. Patrick in Seattle's 1993 St. Patrick Day Parade are, from left to right, Mary Kelly, Mary Mulcahy, Rosella Flanagan, Jim Walsh, and Micheál Keane. For years, Seattle's parade was held on March 17, but in recent years, it was decided that more people could participate if the parade was held on the Saturday closest to the holiday. (Courtesy Mary Kelly.)

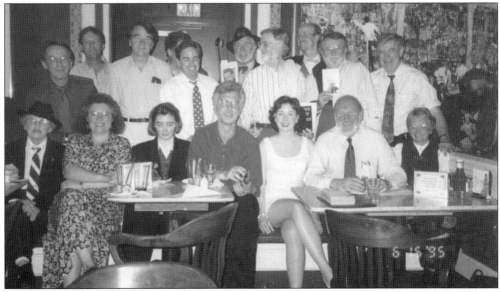

Seattle annually celebrates "Bloomsday," June 16, 1904, the date memorialized in James Joyce's *Ulysses*. Pictured at Seattle's 1995 Bloomsday celebration are, from left to right, the following: (first row) Mary Johnson, Galya Diment, Alice Gannon-McKinley, Dominic Gates, unidentified, Mike Dunne, and Valerie Dunne; (second row) Walt Crowley, unidentified, Patrick O'Donnell, Patrick Cahill, Míceál Vaughan, Paul Ringo, David McCourt, John Keane, and Joe Martin (right background).

The downtown Catholic Seamen's Club, with its history of Irish chaplains, has been a frequent venue for Irish parties and dances, like the one above in the 1980s. The club, which also has non-Catholic chaplains, caters to active and retired seamen, especially those on ships docking at Seattle's port after months at sea. (Courtesy Mary Shriane.)

The winners of the Irish Heritage Club's Halloween costume party at the Catholic Seamen's Club in the 1980s were, from left to right, Frank and Mary Shriane, Anne Murphy, and Margaret Kelly. The Irish Heritage Club is the largest and most active organization in the Seattle area and annually sponsors concerts, plays, lectures, and movies, as well as parties and other social events, in addition to cultural exchanges with Galway, Ireland. (Courtesy Mary Shriane.)

Eight

OLD IRISH AND NEW IRISH—ONE FAMILY

Irish people on the frontier tended to seek each other out for socializing and companionship, and marriage was a frequent outcome of such interaction. The resulting connections through marriage of different Irish families in the late 1800s and early 1900s were common to many Irish communities across the U.S. and were also true in the Puget Sound area. Also common were the connections made between Irish-born individuals and second generation or later Irish. One example of the Puget Sound area's old Irish being united with the Puget Sound area's new Irish was the Dickson-Quinlan wedding in 1962.

Mary "Kay" Dickson was born in Tacoma. All four of her great-grandparents were born in Ireland, and even though all of them died before she was born, it was always stressed to Kay as she was growing up that she was Irish. Stories were told about Ireland, and she and her family took great pride in their Irish ancestry. Letters to and from cousins in Ireland were sent and received on a regular basis even though they had never met. In fact, none of Kay's family had ever visited Ireland until Kay went there after her wedding to Tom Quinlan.

Tom Qunilan was an immigrant to Seattle from County Tipperary in 1957. Upon arrival in Seattle, he immediately got involved in the "Irish scene," playing Gaelic football, attending Irish dances and parties, and quickly got to know many of the Irish people in the area. Tom met Kay at a 25th wedding anniversary for an Irish couple, and they were married in Tacoma on November 24, 1962.

The common thread uniting all of the individuals in the photographs on the following pages, which are provided courtesy of Tom and Kay Quinlan, is that they are related in some way to Kay Dickson Quinlan.

Pictured here is the Dickson-Quinlan wedding party on November 24, 1962. The gentlemen in the photograph are, from left to right, Tom Sampson from County Limerick, Mike O'Malley from County Mayo, Tom Quinlan from County Tipperary, Frank Shine from County Kerry, Pete Carr from Scotland, and Bob Dickson, who was Kay's brother. The ladies in the wedding party are, from left to right, Brenda Sullivan, Mary Ann Dickson, Helen Mulkerin, Kay Dickson, Sandra Fronset, and Kathy Eggan.

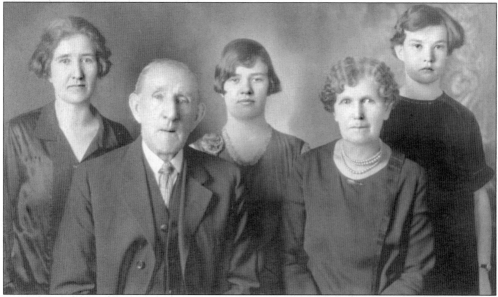

Three generations of Regans pose in Tacoma around 1920. Pictured are, from left to right, (first row) John and Mary Bigelow-Buckley Regan; (second row) daughter Florence and grand-daughters Mary Jane and Margie Hopkins. John and Mary Regan emigrated from County Cork to Tacoma in 1874. Their grand-daughter, Mary Jane Hopkins, later married David Dickson and was Kay Quinlan's mother.

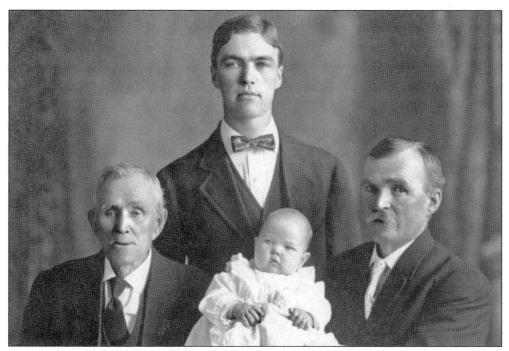

Four generations of Hopkins men pose around 1912. They are Michael Hopkins of County Mayo, Michael's son Teddy Hopkins from County Mayo (right), Michael's grandson John Hopkins (rear), and Michael's great-granddaughter Mary Jane Hopkins, who was Kay Quinlan's mother.

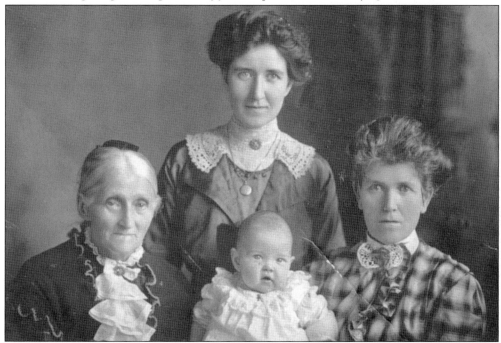

Four generations of Regans pose around 1912. They are Alice Bigelow-Buckley from County Cork, her daughter Mary Bigelow-Buckley Regan (right), Alice's granddaughter Florence Regan (rear), and Alice's great-granddaughter Mary Jane Hopkins, who was Kay Quinlan's mother.

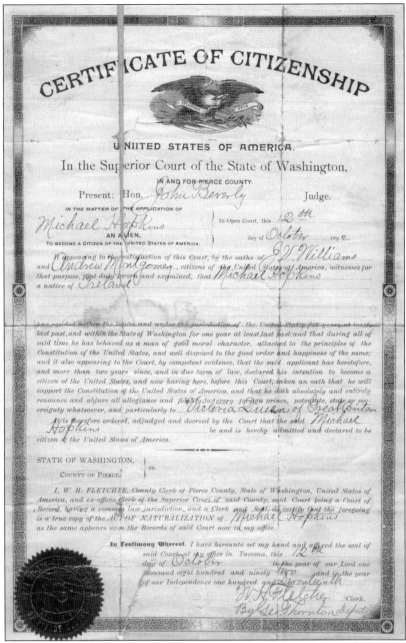

Widower Michael Hopkins (1825–1914) and his son Teddy Hopkins Sr. came from County Mayo to the United States around 1880. Teddy went to Pennsylvania, where he became a citizen in 1888, but Michael had moved to Tacoma, so Teddy followed him in 1895 and became an officer with the Tacoma mounted police. His father, Michael Hopkins, Kay Quinlan's great-great-grandfather, became a U.S. citizen in Tacoma in 1892. His naturalization papers, pictured above, state that "he doth absolutely and entirely renounce and abjure all allegiance and fidelity to every foreign prince, potentate, state or sovereignty whatsoever, and particularly to Victoria Queen of Great Britain." Michael was happy to do the latter, as he never forgot his family's treatment in Ireland under British rule.

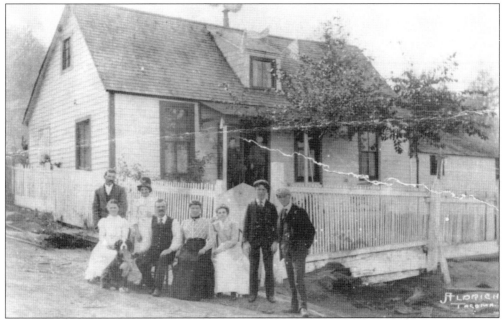

Pictured above around 1905 is the Hopkins family home overlooking Commencement Bay in Old Town Tacoma. Seated in the center are Teddy and Katherine Hopkins. Standing right are son Teddy Jr., who was a union organizer in Tacoma, and son John, who worked at the Tacoma Mill and later became a federal parole officer at McNeil Island Federal Penitentiary. John Hopkins was Kay Quinlan's grandfather.

Pictured here in 1909, John Hopkins, right, Kay Quinlan's grandfather, works as assistant cashier in the old Tacoma office of the Tacoma Mill. Hopkins's salary was $55 per month, a sizable amount in 1909. He later became a federal parole officer at McNeil Island Federal Penitentiary. Shown at left is timekeeper Andy Henson.

Around 1907, Mike and Katherine Buckley Lacey pose on their farm near Olympia with their six children, two of whom are hidden among the tree branches. Mike and Katherine were born in Ireland, and Katherine was Kay Quinlan's grand-aunt.

Mike Lacey and family are shown here in 1914, shortly after Katherine died. Lacey was born in 1854 in County Clare and came to the United States in 1872. He worked on the railroads and on steamboats, drove a stagecoach, and was a logger, fireman, blacksmith, and gold prospector. He ran a hops farm near Puyallup, got into real estate near Olympia, and became very wealthy. Family lore claims that the city of Lacey was named for him.

Nine

REIGNITING TIES TO IRELAND

In 1982, the Seattle-Ireland Sister City Association was jointly formed by Seattle's Irish Heritage Club and the Friendly Sons of St. Patrick to bring about a Seattle sister-city relationship with an Irish city. A group traveled to Ireland that year, and among them were Tom Keefe, then Seattle deputy mayor; Ed Devine, then counselor to Washington governor John Spellman; restaurateur Mick McHugh; Mary Shriane from County Carlow; Fr. Bill Treacy from County Laois; restaurateur Rich Malia; *Seattle Times* columnist Alf Collins; public relations guru Lynne Berry; Jake O'Shaughnessy's "singing bartender," Robert Julien; and John Keane from County Westmeath.

After visits to Dublin, Waterford, Cork, Limerick, and Galway, the group's consensus was that Galway was the city they wanted as an Irish sister city, as it has the most in common with Seattle; it, too, is a lively university city and also is on the west coast; Galway is the gateway to America, while Seattle is the gateway to the Orient; like Seattle, Galway has a fishing fleet; and it is close to wild and beautiful Connemara, just as Seattle is close to the Olympic Peninsula and Rainier National Park. There found tremendous similarities between the two cities, which made the argument for a formal relationship.

In 1986, Seattle and Galway formalized a sister-city relationship, cementing the rapport that actually started in 1982.

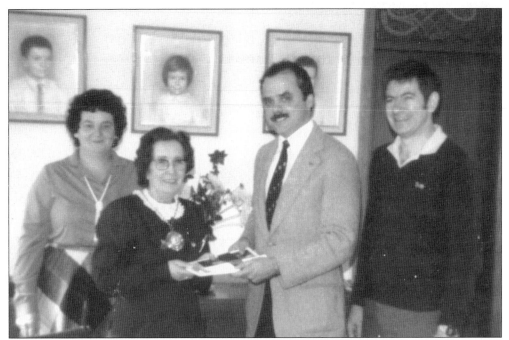

From left to right, Mary Shriane, Galway deputy mayor Mary O'Byrne, Seattle deputy mayor Tom Keefe, and John Keane pose in 1982 during the sister-city visit to Galway. Upon the group's return to Seattle, the push started for the establishment of a Seattle-Galway relationship.

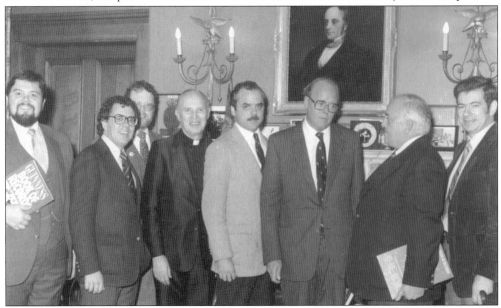

On their 1982 Ireland trip, some members of the Seattle-Ireland Sister City Association met at Guinness brewery in Dublin with Lord Iveagh, the earl of Guinness. Pictured from left to right are Robert Julien, the "singing bartender;" Seattle restaurateur Mick McHugh; *Seattle Times* columnist Alf Collins; Seattle diocesan priest Fr. William Treacy; Seattle deputy mayor Tom Keefe; Lord Iveagh; Ed Devine, representing Gov. John Spellman; and John Keane, Sister City Association secretary.

From left to right, Rich Malia (then owner of Malia's Northwest and now owner of Ponti restaurant) poses with Galway mayor Michael Leahy, Regina Joyce, and John Keane in 1984. Born in England of Irish parents from County Mayo, Joyce was a star athlete at the University of Washington in the early 1980s. She was the 1981 NCAA 3,000-meter champion and finished second at the 1982 NCAA cross-country championships. She represented Ireland in the women's marathon in the 1984 Olympics in Los Angeles and now lives in Lynnwood with her husband, Al Bonney, and their family.

In 1984, Galway mayor Michael Leahy (left) visited Galway Traders, an Irish store opened earlier that year by Hugh Murray (right) and his wife, Eveline. The store is in an old home in Ballard that was built by an Irish contractor in 1912. Every room in the shop is full of Irish items, including Aran sweaters, Irish linen, Celtic jewelry, Irish dancing shoes, Bewley's Irish tea and other Irish foods, and especially Irish books and music CDs. The store is a tremendous resource for anyone wanting to learn about Ireland. (Courtesy Galway Traders.)

Seattle mayor Charlie Royer poses with Galway mayor Bridie O'Flaherty on March 11, 1986, while wearing the Galway ceremonial robes and Chain of Office. They had just signed the Seattle Galway Sister City agreement in the mayor's conference room at Seattle City Hall, formalizing the establishment of a sister-city relationship with Galway.

Pictured here in 1986, Bridie Murray from Foxford, County Mayo, and mother of the Galway Traders owner, meets with Galway mayor Bridie O'Flaherty. As a five year old in 1905, Murray won an Irish-dancing gold medal at the Oireachtas in Dublin. She came to New York in 1921 and, in 1931, married Alf Murray, also from County Mayo. They moved to Seattle in 1968, where Alf died in 1971 and Bridie in 1986. In the background is Galway Traders owner, Hugh Murray.

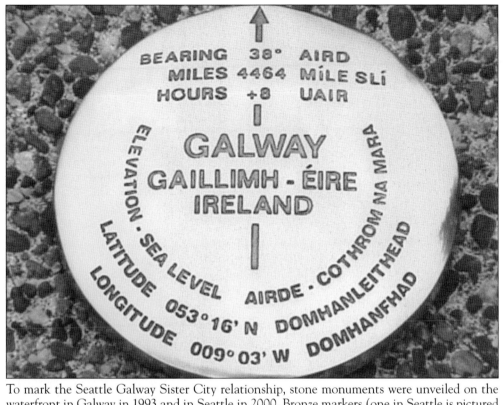

BEARING 38° AIRD
MILES 4464 MÍLE SLÍ
HOURS +8 UAIR

GALWAY
GAILLIMH - ÉIRE
IRELAND

ELEVATION · SEA LEVEL AIRDE · COTHROM NA MARA

LATITUDE 053° 16' N DOMHANLEITHEAD

LONGITUDE 009° 03' W DOMHANFHAD

To mark the Seattle Galway Sister City relationship, stone monuments were unveiled on the waterfront in Galway in 1993 and in Seattle in 2000. Bronze markers (one in Seattle is pictured above) carry the geophysical data of the sister city—its longitude, latitude, distance, and time difference, as well as arrows pointing in the true direction of the sister city, both overland and directly through the earth. The two monuments thus point directly to each other. The Galway Stone in Seattle is at 2200 Alaskan Way, opposite Pier 66.

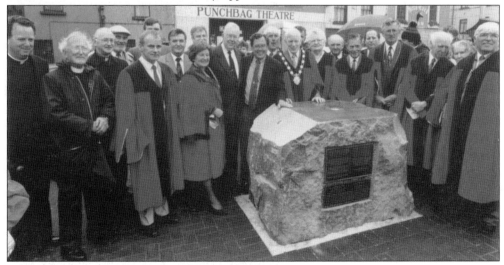

In 1993, Seattle City Council president George Benson and Galway mayor Padraic McCormack, T. D., unveil the Seattle Stone in Galway surrounded by Galway city councilors in their robes. Most of the Galway city councilors in the photograph have visited Seattle.

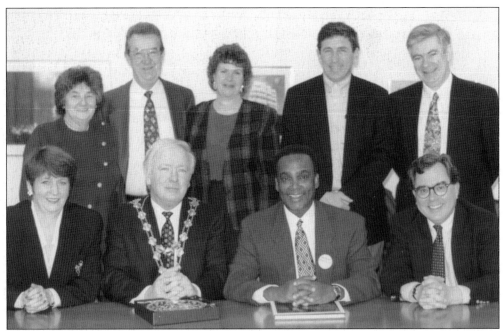

In 1989, sister-city mayors met at Seattle City Hall. Pictured here are, from left to right, the following: (first row) Carol Coogan, Galway mayor Fintan Coogan, Seattle mayor Norm Rice, and Mick McHugh; (second row) Mary Shriane, John and Mary Jo Costello, Tim McGarry, and John Keane. Since the Seattle-Galway relationship was formalized in 1986, Galway mayors have visited Seattle 14 times.

From left to right, John Keane, Dónal McKevitt, Galway mayor Declan McDonnell (standing), and Mick McHugh are pictured here in 2000 at a Seattle Galway Sister City Association dinner. McKevitt is from County Louth.and came to Seattle in 1958. He worked for O'Malley Brothers Construction and, in 1964, started working at Olympic Foundry, later becoming president and owner of the company. A leader in Seattle's Irish community, he's also involved in the Seattle Galway Sister City Association.

Pictured here in 1988 at a Seattle Galway Sister City Association dinner in Seattle's Jake O'Shaughnessy's are, from left to right, Sean Connolly, Hugh Keane, Ann LaPoma, "singing bartender" Robert Julien, Galway mayor Martin Connolly, Fr. Tom McEnnis, Prof. Thomas P. O'Neill, Dónal McKevitt, and Frank Shriane. O'Neill was professor of history at University College Galway and authored the official biography of Irish revolutionary leader Eamon de Valera.

Nobel Laureate Mairead Corrigan Maguire, center, is pictured here in Seattle in 1991 with Ann LaPoma, left, and Maureen Keane, right. Maguire shared the Nobel Peace Prize with Betty Williams in 1976 for her efforts to end the violence in Northern Ireland. Thirty years later, and eight years after Northern Ireland's Good Friday Agreement, Maguire is still involved with the Peace People in Belfast.

SUGGESTED READING

AND RESOURCES

IRISH RESOURCES
Griffin, William D. The Irish Americans. Beaux-Arts Editions, 1998.
Kissane, Noel. The Irish Famine, A Documentary History. National Library of Ireland, 1995.
Sarbaugh, Timothy J. and Walsh, James P., "The Irish in the West," The Journal of the West, Vol. 31, No. 2, April 1992.

SEATTLE RESOURCES
Bagley, Clarence B. *History of King County Washington, Volumes I-IV.* Chicago-Seattle: The S J Clarke Publishing Company, 1929.
Dorpat, Paul. Seattle: Now and Then. Tartu Publications, 1984, 1988.
Morgan, Murray. Skid Road, An Informal Portrait of Seattle. Viking Press, 1951.

LIBRARY RESOURCES
The Seattle Room, Seattle's downtown public library.
The Northwest Room, Everett's downtown public library.

VARIOUS WEB SITES
http://www.eastsideheritagecenter.org
http://www.highlinehistory.org
http://www.HistoryLink.org
http://www.irishclub.org
http://www.irish-seattle.com
http://www.lib.washington.edu
http://www.seattlehistory.org
http://www.wshs.org